DATE DUE	DATE DUE

Kwantlen University College

The Essence of

BLUE

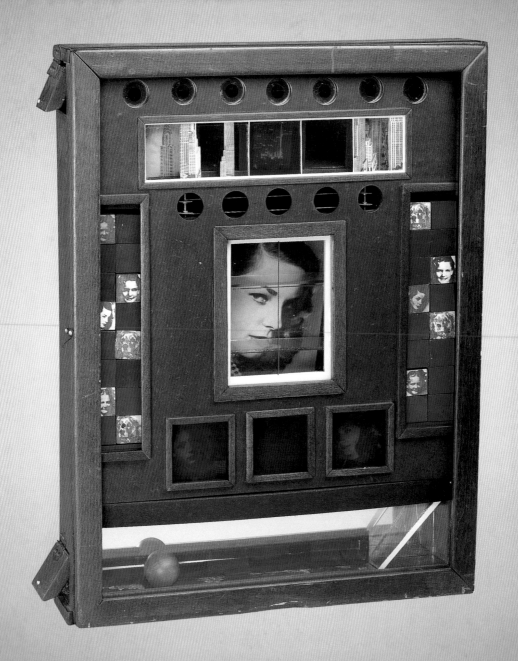

The Essence of
BLUE

Belinda Recio

SALT LAKE CITY

For Mary

ACKNOWLEDGMENTS

I would like to acknowledge the assistance of several people, beginning with my husband, Ed Blomquist, who assisted with research and contributed extensively to "Music in the Key of Blue." Next is Mary Bemis, who also helped with research and consistently shared her ideas and editorial expertise. I am grateful, also, to the following friends for their contributions: Joan Wilcox for her editorial assistance; Lorraine Chernoff for her consultation regarding color analysis; Rebecca Donald for her gemological contributions; and Amy Buckley for her guidance on gardening. Finally, I would like to thank Cathy Kouts for her supportive encouragement throughout this project.

FIRST EDITION

99 98 97 96 5 4 3 2 1

Text copyright © 1996 by Belinda Recio
Image copyrights as noted on page 94.

This is a Peregrine Smith Book, published by
Gibbs Smith, Publisher, P.O. Box 667, Layton, UT 84041

Library of Congress Cataloging-in-Publication Data

Recio, Belinda, 1961-
The Essence of Blue / written by Belinda Recio ;
edited by Catherine Kouts. — 1st ed.
p. cm.
ISBN 0-87905-737-8
1. Color. 2. Blue. 3. Blue in art. I. Kouts, Catherine.
II. Title.
QC495.5.R43 1996
155.9'1145—dc20 95-46324
 CIP

Printed in Hong Kong

Edited by Catherine Kouts and Dawn Valentine-Hadlock
Designed by Larry Lindahl
Cover photograph by John Chard/© Tony Stone Images

Contents

INTRODUCTION: *The Color Blue* p.7

The Mediterranean climate has
inspired some of the bluest
architecture in the world.

THE
COLOR BLUE

I N THE WESTERN WORLD, BLUE IS THE COLOR most people claim as their favorite. Like the blue ribbon, this popular color symbolizes quality and honor. Blue also connotes dignity, virtue, and trust. Only a few friends are worthy enough to be described as "true blue," and such friends are so rare that we find one only once in a blue moon. Blue also projects authority, as embodied in the uniforms of police and air force officers; respectability, through the classic blue of the business wardrobe; and even social rank, where those of eminent ancestry are "blue-blooded."

Artist Wassily Kandinsky believed that the color blue is "a call to the infinite."

However, blue is more than a symbol for virtue and quality—it is the color of heaven and infinity. The French expletive *Sacre-bleu!* and its English equivalent "Good Heavens!" are both blue invocations of the divine. Thus, the color of the heavens—the sacred blue—also symbolizes our search for God and truth. For Christians, the Virgin's mantle is blue for purity; for Hindus, Krishna is the blue of universality; and for Hebrews, blue is the color of the glory of God. Seen from space, even the Earth has a blue signature. Closer to home, blue is the color of the sea and sky, of the jewel-like wings of morpho butterflies, of Wedgwood and blue jeans, and sometimes, of sadness.

Just as the sapphire, the quintessential blue stone, was believed to be endowed with the power to conjure ghosts, the color blue awakens our own spirits. Blue invites us to wonder and wander, to contemplate and explore. Blue's passive and receding nature is alluring. Nature makes the most of blue's attraction—the blue bioluminescent lights at the tips of squids' tentacles are used as lures for prey. Artists know that the receding nature of blue creates distance and thereby draws viewers into paintings. The Russian artist Wassily Kandinsky believed that the color blue is "a call to the infinite." The expanse of the blue sky draws us out of ourselves and into the blue. Blue beckons—and we follow.

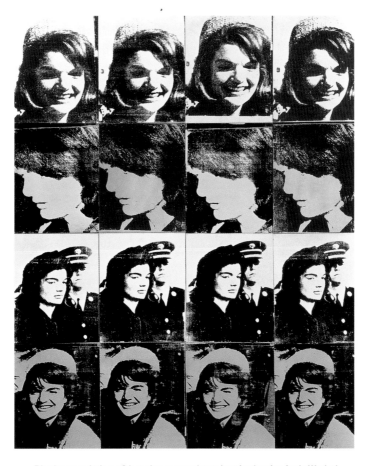

Blue's association with sadness may have inspired artist Andy Warhol
to use the color in this print, which includes portraits of Jackie Kennedy
both before and after the assassination of John F. Kennedy.

The color blue is associated
with introspection and spiritual
contemplation.

FEELING
BLUE

From Serenity to Detachment: The Psychology of Blue

A LL COLORS AFFECT OUR MINDS AND EMOTIONS, and blue is no exception. Despite the associations between blue the color and blue the state of mind, psychologically, blue is first and foremost a calming color, associated with meditative states and quietude. Blue promotes relaxation—the prerequisite of introspection and spiritual contemplation. Consider the great environmental blues—the sea and sky. These vast expanses of blue are nearly hypnotic in their beckoning invitations to "space out." Anyone who has reclined in a grassy field and stared up into the

The wild blue yonder offers a seductive lure to those inclined to daydream.

sky knows how easy it is to be seduced by the wild blue yonder.

However, the color blue elicits more than just peaceful daydreams—it actually relaxes our nervous systems. Therefore, many physicians paint their waiting rooms various tints and shades of blue to help their patients relax. Some people believe that blue is so effective in reducing angst, that the color has been used as a deterrent to suicide. The Blackfriar Bridge in London had been the location from which many people jumped to their deaths. The city repainted the bridge blue in an attempt to reduce the number of suicides—and it worked. It follows, then, that the color blue is used extensively in modern, industrialized society, meeting an ever-increasing need for stress reduction.

Blue is also the preferred color of the business world, where it takes on traditional and conservative characteristics. Dark blue in particular is the ubiquitous color of business suits because it inspires confidence in its wearer and projects stability. According to color studies, blue also appeals to intellectuals and introverts.

Not surprisingly, it is the color of the academic robes worn by philosophers at American universities. Through color experiments, researchers have discovered that children tested in rooms with blue ceilings scored as much as twelve points higher on their IQ tests. Similar studies indicate that rooms with blue interiors enhance children's creativity.

The color blue can evoke sorrow, melancholy, loneliness, and even depression.

Blue affects our perceptions—time seems to pass faster in a blue room or when we are bathed in blue light. Objects appear to be smaller and lighter. Because of these effects, blue—especially turquoise—is considered a good color for a room in which tedious work is done, such as a kitchen or laundry.

Blue can have the blues, however. Like the mournful music of the same name, the color blue can evoke sorrow, melancholy, loneliness, and even depression. The same blue spaciousness that feels so soothing can become bleak and alienating after prolonged exposure.

Blue in the Eye of the Beholder

IN ORDER FOR US TO SEE BLUE or any of the colors of the spectrum, light reflected from an object must enter our eye through the cornea, pass through the pupil and lens, and land on the retina. The retina has two types of light receptors—rods and cones. Only the cones can distinguish between different colors. There are three types of cones, loosely referred to as the blue, green, and red cones, each containing its own light-sensitive pigment that absorbs certain colors better than others. We see color as the result of unequal stimulation of these three cones. When both the blue and green cones are activated in just the right amounts, the cones transmit signals along the optic nerve to the brain, and we experience the color we call blue.

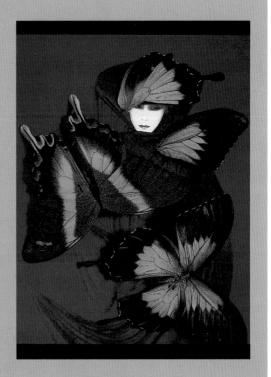

The Blue Person

People who are strongly drawn to blue tend to be devoted and deliberate in their actions. Because blue is everywhere—in the sky above and water below—these people feel a unity with the world. Blue people seek harmony between themselves and others, and they are the "true blue" friends who personify trustworthiness and loyalty. Blue people are peacemakers. They have a serene sensitivity that easily segues into empathy. Dedicated to their dreams, blue people often achieve their aspirations through hard work.

However, all is not blue skies with those who favor blue. Blue people may be self-righteous about their blue-ribbon character traits. They may become conservative and lose their spontaneity. Self-moderation and cautiousness may drive blue people to emotional detachment and even a cool heart. With too little emotion, the blue person risks the frosty aura of ice blue.

Rather than feeling an attraction for blue, some people experience a longing for it. These blue people wish for a life filled with the blue of maternal love—represented in Christianity by the blue cloak of the Virgin Mary—with its accompanying qualities of devotion, patience, and nurturing.

In contrast, people with a strong dislike for blue may be rebellious or bitter and resent the success of others. These anti-blue people may experience difficulty relaxing. They may be impatient, stubborn, and unyielding. Some psychologists claim that people with a strong dislike of blue often change their preference after making peace with themselves.

"Blue people" follow their dreams and often achieve them through hard work.

Dreams of Blue

THROUGHOUT THE AGES, dreams have been considered messages from the spirit world, prophecies, indications of physical health, and reflections of personality. Modern ideas about dreams are based primarily on the theories of Sigmund Freud and Carl Gustav Jung. Freud believed that many of the emotions and desires repressed during wakeful thought find expression in our dreams. Among other things, Jung believed that dreams help us draw conclusions about ourselves and the larger human consciousness of which we are a part. Jung developed the theory of the "collective unconscious," which he described as "the vast historical storehouse of the human race." Within this storehouse are the archetypes—mythological symbols and motifs—that appear in our deepest and most universal dreams. Jung created the term "grand dream" for those dreams that originate in the collective unconscious. Dreams in which bright colors are featured may indicate the possibility of a "grand dream."

SHADES OF MEANING

There is no such thing as a "universal" dream interpretation, because dream images are very personal. However, over the course of human history certain common symbols have become associated with particular conditions and prophecies. When blue is featured predominantly in your dreams, the specific shade of blue is especially important. For example:

⌁ A dazzling azure blue suggests that you may be promoted, take a vacation, or embark on an exciting new project. Essentially, you may be about to "fly into the wild blue yonder."

⌁ Dark or navy blue signifies that you may be depressed, and may need a little romance or excitement in your life. On the other hand, navy blue can represent money coming your way through other people.

⌁ Sapphire blue (or a sapphire itself) connotes a personal search for, or attainment of, truth.

The Color of Relaxation: Healing with Blue

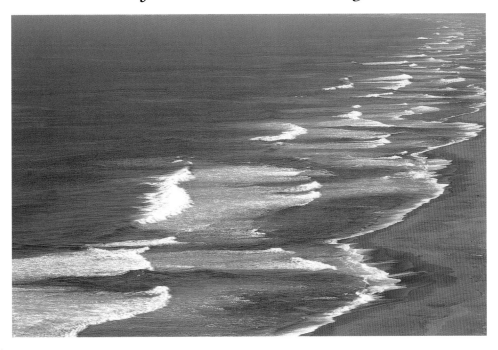

The calming sensation of staring at the wash of waves on a shore is more than meditation—even traditional medicine acknowledges that the color blue has a relaxing effect on people.

THE MEDICINAL USE of color dates as far back as the ancient Egyptians, who used gemstones, solarized water (water infused with the wavelength of a specific color by encasing a vessel of water in glass of the desired color and then placing it in direct sunlight for a prescribed time period), and colored light therapy to treat a variety of ailments. Indian Ayurvedic medicine, which is still practiced today, sometimes uses color for healing. One aspect of Ayurvedic medicine regards the body as being comprised of *chakras*, or energy centers, each of which is associated with one color of the visible spectrum. When someone is ill, practitioners search for energy imbalances, and treat these imbalances with

Vintage Blue
Brewed at Home

WHY BOTHER WITH THE GLASS OF WINE when you could enjoy a relaxing glass of blue water? You can make your own solarizer that captures the energy of the blue wavelength in a glass of water. To make a blue-water solarizer, all you need are three panels of blue glass, approximately six inches wide by ten inches tall (available from your local glass dealer or craft supply shop). Shape the three panels into a triangle and attach the edges with seams of two-inch-wide cellophane tape. Put the solarizer in direct sunlight, fill a clear glass with water, and place it in the center of the solarizer for about an hour. (Note: if you can't find colored glass, try blue cellophane attached to a cardboard frame.) Take a few sips every ten minutes. As a result of the blue energy, the water may develop a sweet flavor, so if you prefer a "dry blue," you're probably out of luck. Nonetheless, color therapists claim that the home-brewed blue will relax and soothe your nerves.

colored lights or gemstones, among other things. In Ayurvedic medicine, the blue chakra is associated with the throat.

Modern medicine has generally regarded the use of color with skepticism. However, when the Danish scientist Niels Finsen won the Nobel Prize for physiology (1903) for the application of light in the treatment of skin diseases (including a form of skin tuberculosis), attitudes changed somewhat. At present, the skepticism seems to center on the use of color in the visible spectrum as opposed to the wavelengths bordering the visible spectrum, such as infrared and ultraviolet, both of which are used by modern medicine. Despite the medical community's hesitant acknowledgment of color's potential in medicine, blue light has earned a solid reputation as a treatment for pathological jaundice in newborn infants. Babies suffering from jaundice turn a yellowish color and, if untreated, can develop brain damage, deafness, and impaired muscular reactions. Many hospitals and clinics treat the jaundice with blue light from special lamps.

Additionally, traditional medicine acknowledges that the color blue has certain physiological effects such as reducing blood pressure and decreasing hormonal activity.

Color therapy, a nontraditional approach to the use of color in medicine, is based on the premise that because color is a product of light, it possesses energy in the form of vibrational frequencies. Like Ayurvedic practitioners, color therapists believe that color energy can be used to correct imbalances in the body and mind. Through treatment with colored lights, baths, blankets, and even clothing, the energy from a color is applied to the patient. Generally, color therapists recommend that their treatment should be an adjunct to traditional medicine and not a replacement. Color therapists use the color blue for a wide variety of conditions, such as high blood pressure, anxiety and hypertension, migraine headaches, and respiratory problems, particularly asthma. Blue is used to reduce muscle spasms, including those associated with asthma. Color therapists believe that even the simple act of wearing blue can reduce the intensity and frequency of asthma attacks. Due to its calming, sedative effects, blue is also prescribed as a cure for insomnia, for which color therapists recommend not only blue light but also blue sheets and blue pajamas.

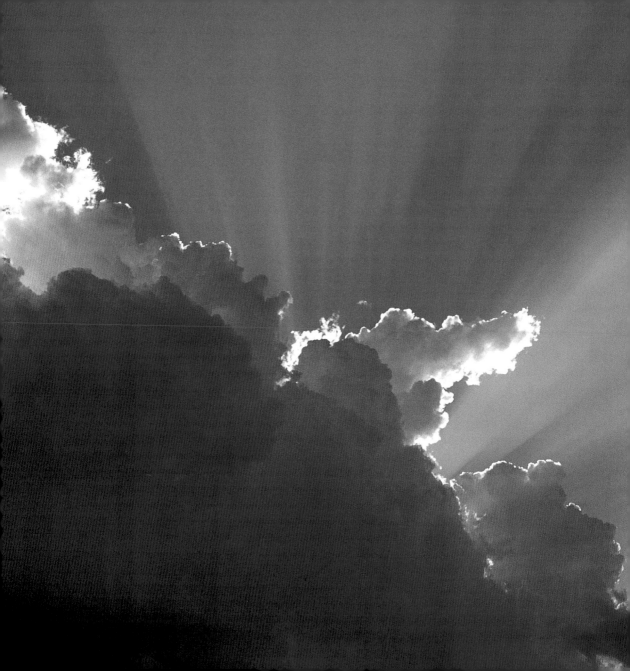

The symbolism we associate with blue ranges from the heavenly bliss of religious devotion to the melancholy depths of depression.

SEEING BLUE

Blue Symbolism

THE GERMAN AUTHOR AND PHILOSOPHER Goethe described blue as a "contradiction between excitement and repose." Blue's protean nature explains why an azure sky heralds hope and promise, yet a midnight sky of indigo is a restful meditation. Similarly, a calm turquoise sea is dreamy and serene, whereas a stormy steel blue sea is a tempestuous fury. Whether flying into the wild blue yonder or sinking into a blue mood, the symbolism we associate with blue rides a vertical axis that ranges from the heavenly bliss of religious devotion to the melancholy

21

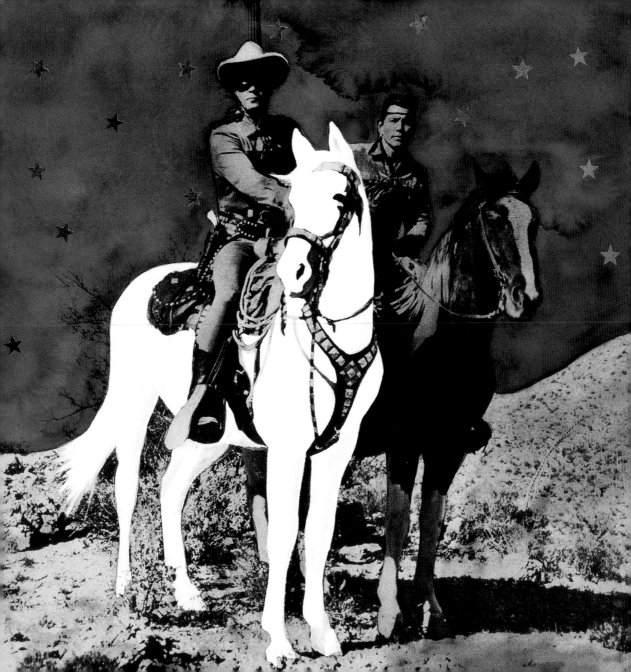

depths of depression, from the intimate "bundle of joy" of a newborn baby boy to the impersonal abstraction of infinitude. Although the specific qualities associated with the color blue vary from culture to culture, numerous symbolic themes recur. Some of these themes are derived from associations with the physical world, and others echo religious beliefs.

The two great blues of the natural world—the sky and the sea—gave rise over the ages to symbolic associations that became metaphysical. The deep blue sphere of the sea, teeming with mysterious life, was, until recently, largely unknowable and impenetrable. Therefore, blue became associated with secrets and hidden knowledge. Earth's other blue expanse—

Blue's symbolic link with law and order is as ancient as the blue breastplates of the early Egyptian priests and as contemporary as the Lone Ranger.

the sky—reinforced and extended the symbolic association with mystery. The gods and goddesses of so many cultures inhabited the heavens that blue became the color most associated with divinity and its attributes of truth, hope, devotion, fidelity, and order. Because humans interact with the divine through prayer and meditation, blue eventually became known as the color of the mind.

However, the interaction between the terrestrial and celestial has always been cloaked in mystery; therefore, the blue of the sky, like that of the sea, is also symbolic of all that is unfathomable and uncharted, unknown and unending. For this reason, a mysterious disappearance is described as a vanishing "into the blue," and an unexpected occurrence or arrival appears "out of the blue." Once again, Russian artist Kandinsky captured the expansive essence of blue when he wrote that blue is

"the infinite penetration into the absolute essence—where there is, and can be, no end."

THE COLOR OF THE MIND

Blue is a color with rich significance in the intellectual realm. In ancient Britain, the Druids were considered to be the educated class, and their school had three divisions—scholars, poets, and priests. The second division—the poets—were called bards, and they wore sky blue robes that symbolized the principles of truth and harmony. Within the Druids' school were unrecorded secret teachings that could only be communicated through an oral tradition. Today, these secret teachings are allegedly known by members of the Blue Lodge of Masonry. In the United States, blue remains the preferred color of mind and intellectual achievement. At American universities, blue is the color assigned to faculty

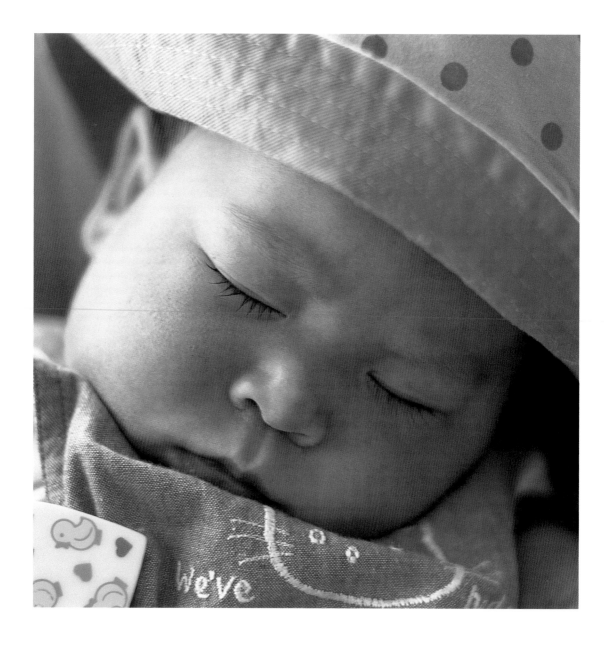

members of philosophy departments because blue embodies our search for truth and wisdom. During commencement ceremonies, these faculty members wear their blue tassels or robes as part of their philosophers' insignia.

BLUE TALISMANS

Blue, perhaps because it is the color of divinity, also represents protection from evil. Many Mediterranean cultures use blue talismans and signs for protection against *el-Ain*, the evil eye. In Armenia and other countries in the Near East, blue stones and glass are believed to ward off evil; consequently, many parents pierce the ears of newborn babies with blue

Although dressing baby boys in blue is primarily considered a modern fashion practice, this tradition may have its roots in the ancient belief that baby boys were a gift from the gods, who would grow to provide for the family.

earrings. In France, Christian mothers dress their little girls in blue as a reflection of the Virgin's blue mantle. Polish Christians living in rural areas are reported to paint the houses of virgins blue, also after the Virgin's mantle. The Amish of the United States are said to practice a similar custom: their gates are often painted blue, which is believed to designate the home of a preacher. However, according to rumor, the blue gates are sometimes used to signify that a daughter is ready to marry. In the United States and some parts of Europe, however, blue is more often associated with boys, especially as a color of dress, which is considered a modern fashion practice rather than an overt symbolic gesture.

THE MOST NOBLE ORDER OF THE GARTER

Not all relationships between women and the color blue have had the elevated status of

divinity. Since the Middle Ages, there have been superstitions surrounding women's garters: if a woman's garter slipped off, it was believed to be a sign that her lover would be unfaithful. A blue garter, however, was said to be a protection against such unfaithfulness (which is why brides wear blue garters under their wedding gowns). The connections between the color blue, a garter, and honor were immortalized in a story from fourteenth-century England. A blue garter slipped off a lady in the presence of King Edward III. When the king stopped to retrieve the garter, bystanders laughed. The king later rebuked them with the words *"Honi soit qui mal y pense,"* or "Shame to him who thinks ill of it." The king commemorated the moral of this story by founding the Most Noble Order of the Garter, and his rebuttal became the motto of the Order. Thus, an order of knights named after a blue garter is the origin

of the "blue ribbon," which symbolizes the highest honor or best quality.

GOURMET BLUE

Blue's symbolic association with quality was mirrored across the English Channel in France. A knight in the French Order of the Saint Esprit (Holy Ghost) was known as a *Cordon Bleu* (Blue Ribbon) because the insignia of the order included a blue ribbon. These knights regularly dined together in a supper club and were known for their gourmet cuisine. As a result, the title *Cordon Bleu* came to be informally bestowed upon those with extraordinary culinary skills. Blue's connotations of quality and excellence reach into many other areas. For instance, in poker, a blue chip has the highest value. Consequently, in the jargon of the stock market, a "blue chip" investment is regarded as a high-yielding, low-risk purchase.

THE OTHER BLUE

Blue, however, has not always been associated with excellence and honor, purity and grace. In fact, it has often symbolized the polar opposite of these qualities. The term "blue gown" once referred to prostitutes who were incarcerated in correctional institutions that required them to wear blue uniforms, supposedly to distinguish them from other inmates. However, one wonders if the color blue was chosen only as a matter of contrast—perhaps the officials were tempted to redeem the prostitutes by requiring them to wear the color of the Virgin. Along the same lines, a "blue movie" is considered to have indecent or sexually obscene content, and a "blue joke" is generally not appropriate for mixed company.

When Mitch Rider and the Detroit Wheels sang "Devil in a Blue Dress," they were singing about a temptress in disguise. However, in the late 1700s, to have the "blue devils" was to be in a state of severe melancholy, possibly as a result of possession by a "baleful" demon. Not quite so extreme is the more common use of the word "blue" to describe a person in low spirits, and "the blues" to describe depression or sadness. Historians believe that in 1807 Washington Irving may have been the first to use the expression "the blues" as an abbreviation for the "blue devils."

In the eighteenth century, the term "bluestocking" was a derisive term used to describe women who preferred to engage themselves in pursuits of the intellect rather than activities considered more appropriate for women. Historians believe that the term originated when a male guest declined an invitation to a social event with a group of these *femmes savants*. The gentleman offered the

The ambiguous symbolism of blue— pure or tainted—is well expressed in this photo collage portrait.

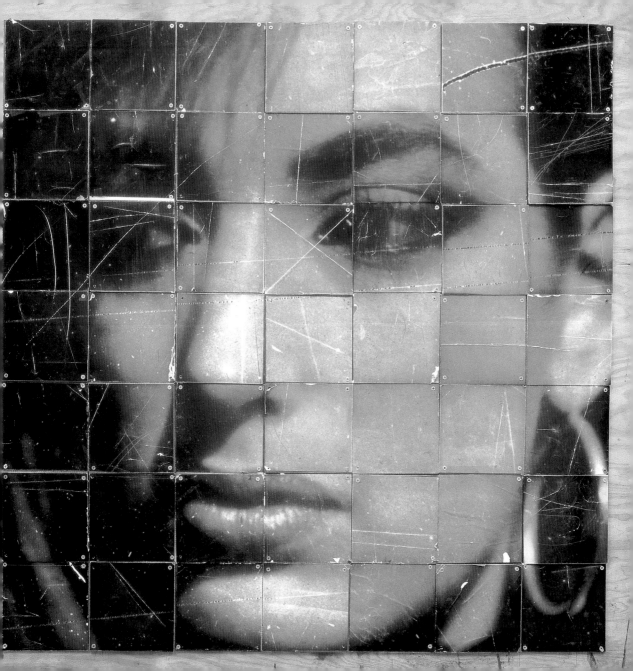

excuse that he lacked appropriate attire. The women, characteristically unconcerned with such frivolous matters as fashion and decorum, insisted that the guest accept the invitation regardless and attend in his "bluestockings," an article of clothing considered informal at the time. The women soon found themselves referred to as "bluestockings," first as a harmless allusion to informality and later as a colloquial term for a female pedant lacking in the feminine graces.

Blue Laws and Warriors

At the other end of the spectrum, blue is associated with the highest ideals of human morals and behavior. The blue breastplates of the Egyptian priests represented truth and justice, as does the blue field on the American flag. Blue's symbolic link with law and order may have originated with the legend that the tablet upon which the biblical Ten Commandments were carved was a large sapphire. The New England Puritans solidified blue's association with moral law when, in 1781, they printed a list of Sabbath regulations on blue paper. The regulations, which were the Puritans' attempt to enforce the laws of God that forbid secular activities on Sundays, became known as "blue laws." Today, secular laws are enforced by the "boys in blue," an American colloquial expression for the police. In Britain anyone in a blue uniform might be referred to as a "bluebottle," and British parliamentary reports are sometimes bound with a blue cover and are therefore called "Blue Books."

In 1943, the DuPont corporation took a different approach to codifying blue as the color of authority. The company enforced a safety color code now in widespread use throughout U.S. industry. According to this color code, any piece of equipment marked with blue must not be operated without official authorization. Blue is also a major color in the U.S. government and the military—from the predominantly blue seal of the United States to the color of fleet planes reserved exclusively for the use of the president to the formal blue uniforms of the Air Force and Marine Corps.

The Roman emperor Julius Caesar may have encountered the most conspicuous use of blue in the military when he invaded Britain in 55 B.C. There he and his troops met an army of savage warriors whose shaved bodies were painted blue with a dye made from the woad plant. Blue was considered a sacrificial color; therefore, the ritual of painting their bodies blue prepared the Britons for battle, which, according to Caesar's reports of their ferocity, they must have considered a form of self-sacrifice.

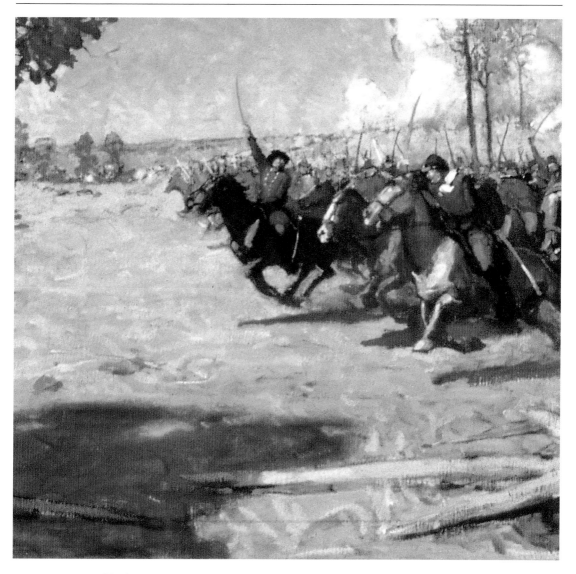

Blue has always been a battle color and was worn by Union soldiers in the Civil War.

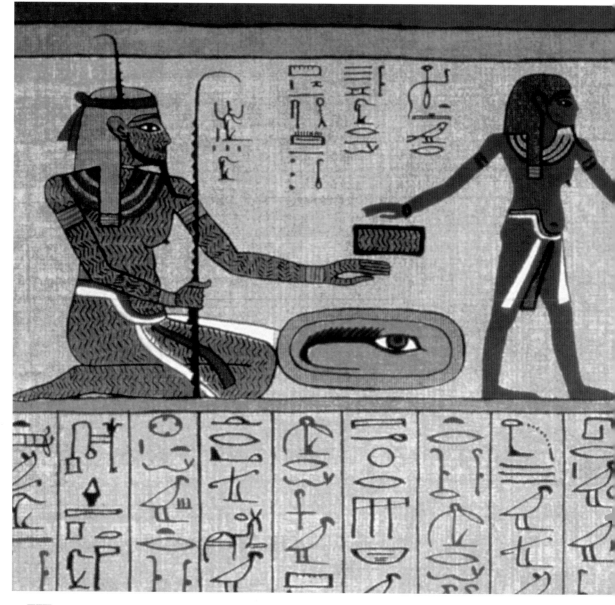

Blue Deities, Legends, and Mythologies

HEAVENLY BLUE GODS AND GODDESSES

*I*N ANTIQUITY, GODS WERE often associated with a particular color. The Roman god Jupiter was designated as heavenly blue, and his wife, Juno, was sometimes depicted wearing a blue veil. Gods were believed to possess specific qualities as well as colors. For example, Jupiter, the blue god, represented honesty, morality, prudence, and ambition. In Egypt, many temple and manuscript hieroglyphs include illustrations of Osiris, the Egyptian god of the underworld, who was sometimes colored blue. In the Hindu faith, the blue god Krishna—who was sent to Earth to save it from evil spirits—is worshiped as the eighth incarnation of the god Vishnu. Krishna's color symbolizes his universality, which is like the blue of the sky that blankets the world, and his divine mystery, which is like the blue of the unfathomable depths of the sea.

In Tibet and Nepal, the Buddhist goddess known as Blue Tara is invoked to destroy enemies and obstacles. She is one of the most terrifying deities of the Mahayana Buddhist pantheon. Blue Tara is usually depicted as being blue in color, with her tongue thrust through a mouth of fangs, and a third eye on her forehead. Adorned with a

Osiris, the Egyptian god of the Underworld, was sometimes depicted as green and sometimes as blue. In this illustration from the Egyptian *Book of the Dead*, he appears as blue.

Krishna's blue color symbolizes his universality.

wreath of severed heads and snakes, she carries an assortment of weapons in her two to twenty-four hands.

For the Hebrews, blue is the color of God and divine glory. Throughout the Old Testament there are several examples of God's preference for blue. In Exodus, Moses and a host of elders saw the God of Israel stand on a "paved work of sapphire stones," and in a vision, Ezekiel describes the throne of God as constructed of sapphires. God also advises Moses to "speak unto the children of Israel, and bid them that they make fringes in the borders of their garments, throughout their generations, and that they put upon the fringes of the borders a ribbon of blue . . . that ye may remember, and do all my commands, and be holy unto your God." In Jerusalem, blue hands painted on doors are believed to protect the people dwelling within. Today, the

Probably one of the best known of all Christian uses of color symbolism is the blue mantle of the Virgin.

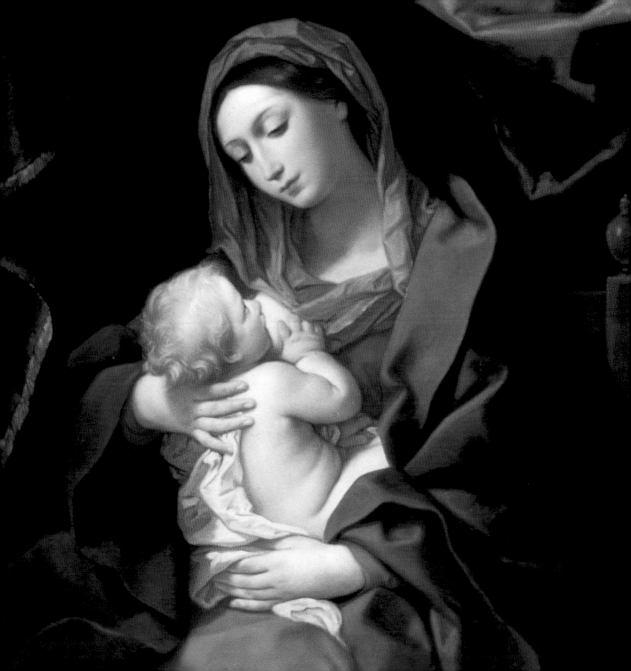

blue-and-white flag of Israel, as well as the blue decorations associated with the contemporary celebration of Chanukah, reinforce the connection between the color blue and the Hebrew faith.

In the Christian heavenly trinity of Father, Son, and Holy Ghost, the Father is represented as blue—possibly as a holdover from the Judaic tradition. Probably best known of all the Christian uses of color symbolism is the blue mantle of the Virgin Mary. The Virgin's mantle is blue because this color represents hope, purity, piety, and devotion. Color was also very important in Christian visionary experience, and visionaries frequently identified and described nuances of color with a level of detail far ahead of their times.

Jakob Boehme, a German

Blue is often associated with divine glory.

theologian and mystic, understood color as one of the ways that God manifested His divine essence. In several of Boehme's visions, colors are associated with angels, and he describes the individual angels according to the colors of their spiritual focus, explaining that angels get their colors "as the flowers in the meadows, every one receiveth its color from its quality." According to Boehme, the angels that have the qualities of love and heavenly joyfulness as their strongest focus are light blue in color, and are full of bright, sparkling light. That the angels of love and joy should have the same color signature as the sky is a metaphor most people would embrace while staring into the heavens on a clear day.

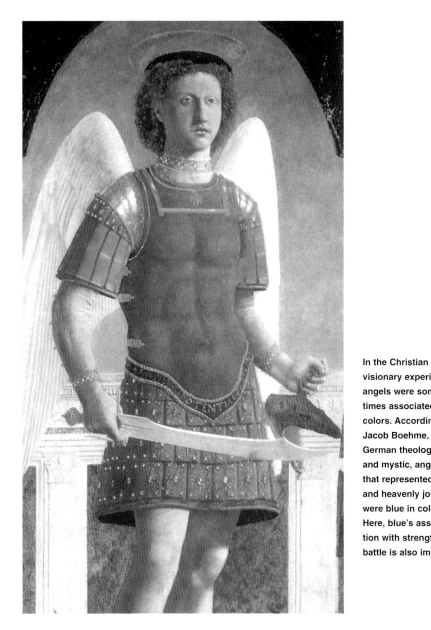

In the Christian visionary experience, angels were sometimes associated with colors. According to Jacob Boehme, a German theologian and mystic, angels that represented love and heavenly joy were blue in color. Here, blue's association with strength in battle is also implied.

A Blue by Any Other Name

IN 1810, THE GERMAN AUTHOR AND PHILOSOPHER GOETHE pointed out the curious absence of words for the color blue in Greek Homeric poetry. As the Greek landscape doesn't suffer a lack of blue hues, this absence impressed many scholars as peculiar. Modern scholars have ruled out the possibility of widespread color blindness and are instead considering the cultural conditioning that affects color perception. For some cultures, precise distinction between hues is very important; for others, however, qualities such as the brightness or darkness of a hue is more important. Scholars may have solved the mystery when they discovered that the ancient Greeks used the word *kyanos* to describe the blue mineral we call "lapis lazuli." They used this same word extensively as an adjective meaning "dark." Thus, hair, storm clouds, and other dark objects were described as *kyanos*. For the ancient Greeks, blue may have been more a quality of darkness than a distinct color.

THE BLUE MEN OF MINCH

Blue is not reserved solely for divinity—many creatures of mythology are associated with the color blue. In the Western Isles off the northwest coast of Scotland, in the strait between Long Island and Shiant Island, unlucky sailors sometimes found themselves in the company of the Blue Men of Minch. These mermen were believed to be fallen angels, and were known for their ability to conjure violent storms. In fact, fair weather indicated that the Blue Men were asleep. Dangerous as these Blue Men were, when threatened by one, all one needed to do was speak in rhyme. The Blue Men of Minch were easily flustered by verse, and clever rhymes were reported to have saved many sailors' lives.

BLUE SPIRITS

Blue can be a very ghostly color, and many people who have reported sightings of ghosts describe the apparitions as having an eerie blue color. There's an old superstition that says when a candle flame burns blue, spirits are present. When artists paint ghosts, souls, and other spectral phenomena, they frequently color them blue. Ghosts that haunt watery places are almost always reported to be blue. Over a century ago, at a hotel in Scotland, a little boy was sleepwalking when he wandered into a nearby lake. He drowned, and when his body was finally located, the icy water had turned his body

blue. According to legend, the blue ghost of the drowned boy haunts the hotel to this day. Recently, Masterpiece Theatre produced *The Blue Boy,* a movie based on this story. The film relies on blue lights to create an atmosphere of haunting and ghostliness.

CLOSE ENCOUNTERS OF THE BLUE KIND

Ghosts, however otherworldly they may seem, are nonetheless considered to be the spirits or souls of *earthly* creatures. What of the possibility that mysterious phenomena are not from this planet? The question of whether there is life elsewhere in the universe has been around since ancient times, and many civilizations kept records of sightings of strange phenomena in the sky. In 1561, in Nuremberg, Germany, there were published reports of blue, black, and red "plates" that appeared in the sky above the city. More recently, in March of 1952, the U.S. Air Force founded Project Blue Book to investigate the validity of UFO reports. The Air Force assembled a panel of scientists in such fields as astronomy, engineering, and meteorology for Project Blue Book. By the time the project was closed in 1969, Project Blue Book had investigated 12,618 reported sightings and events, 11,917 of which had been explained or dismissed as aircraft, balloons, or natural phenomena; 801 remain unexplained. Project Blue Book attempted to answer the question: "Are we alone?" Reportedly, it was a quest for the truth. Yet, the project's records were confidential and were not disclosed to the public. Consciously or not, by calling the project "blue," the Air Force evoked one of the classic dichotomies of this enigmatic color—blue simultaneously represents both truth and mystery.

In 1958, a singer named Betty Johnson recorded a song called "The Little Blue Man." It was about a small blue extraterrestrial that persisted in following the singer, proclaiming his love for her. In 1995, *Close Encounters of the Fourth Kind,* a book about the alien abduction conference held at the Massachusetts Institute of Technology, was published. The book includes many accounts of alien sightings and abductions. Contrary to the tradition of depicting aliens as little green men, most of the aliens described by the abductees at the conference were gray, and some were bluish gray or had a "bluish tinge." In many of the abductees' reports, a blue light is seen just prior to the arrival of the spacecraft or appearance of the alien entities, as if to visually announce the onset of the inexplicable.

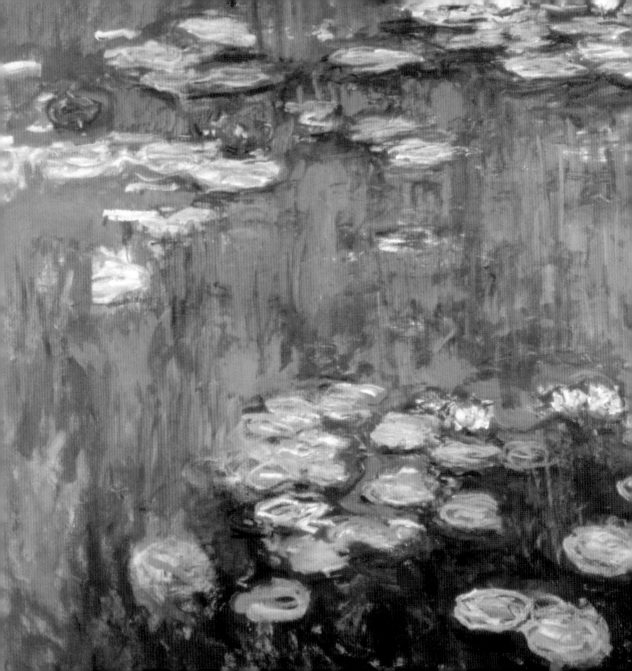

The dominance of blues is one of the color signatures of the Impressionist palette.

CREATING BLUE

From the Madonna's Mantle to Cobalt Men: A Blue Retrospective

BLUE'S SYMBOLIC ASSOCIATION WITH SPIRI-tuality is evident throughout the history of art. Whether in the Madonna's blue mantle in Christian paintings or in the illuminated blue screen of Derek Jarman's film that chronicles his descent into blindness and death, the color blue often signifies a sacred state or spiritual quest. Even when blue is not employed as a symbol of spirituality, there still exists a quality about this transcendent color that inspires the reach for perfection. Josiah Wedgwood conducted over 10,000 color trials before he finally arrived at the

serene, dignified color that is now recognized throughout the world as "Wedgwood Blue." French artist Yves Klein was so obsessed with blue that he developed his own blue—"International Klein Blue"—and is said to have patented it. Below are selected examples from the wide spectrum of blue associations in the world of art.

THE DIVINE DARKNESS THAT TRANSCENDS LIGHT

Scholars have determined that in both the Judaic and Christian traditions, the "Light of God" was thought to be too bright to see; therefore, Christ was said to emanate a darkness. This divine darkness—the Light of God—was believed to manifest itself as the color blue, a color sacred enough to have the honor of representing the Holy Light, yet humble enough to be seen by the human eye. In certain depictions of the Transfiguration—the manifestation of the Holy

Ghost in Christ—the robes of the disciples turn a deep blue where the rays of Christ's darkness fall upon them. This rendering may have its roots in accounts of the Transfiguration in which blue is described as the divine darkness that transcends light.

In countless examples of Christian art, blue is the color of heaven, saints, angels, and most especially the Virgin Mary, whom Dante described as "the sapphire who turns all of heaven blue." The tradition of depicting the Madonna in a blue mantle is believed to have originated in the icons of the Greek and Byzantine civilizations. However, almost simultaneously, Italy established its own commitment to the Virgin's blue mantle. Two Italian artists of the fifteenth century, Fra Angelico and Filippo Lippi, are renowned for their individual paintings of the Madonna in her blue mantle and for their collaboration on a "tondo," or round

painting, called *The Adoration of the Magi*, in which both Mary and Joseph are wearing blue. Flemish artist Jan van Eyck used layers of rich glazing to create a sense of illumination in his painting of the blue-robed Virgin in *The Annunciation*. In Lorenzo Monoco's *The Coronation of the Virgin*, Christ himself wears a blue robe as he places a crown on Mary's head, which is draped with a blue cloth.

KANDINSKY'S BLUE SPIRITUALITY

Russian artist and aesthetic theorist Wassily Kandinsky is generally regarded as one of the founders of abstract art. He is also considered one of the great colorists of the twentieth century. Kandinsky pursued a visual language that was

As blue is a very spiritual color, it is no surprise that it dominates many paintings of the divine, as seen here in *Angel* by Vincent Van Gogh.

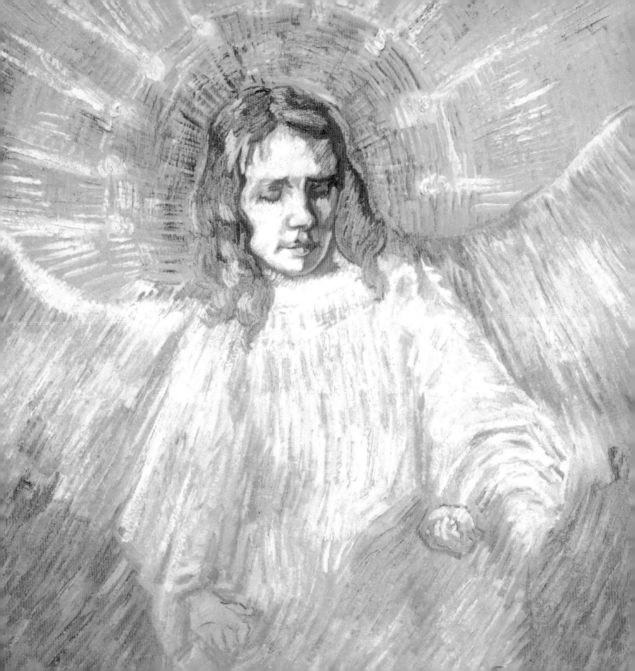

abstract—a system of color
and form that was released
from the cumbersome obliga-
tion to depict recognizable
objects—in much the same
way that "musical language"
is abstract. He considered color
a "thought form," and believed
that colors should be used only
for their symbolic and emo-
tional content. In *Concerning
the Spiritual in Art*, Kandinsky
wrote: "Generally speaking,
color is a power which directly
influences the soul. Color is
the keyboard, the eyes are the
hammers, the soul is the piano
with many strings. The artist is
the hand which plays, touching
one key or another, to cause
vibrations in the soul."

For Kandinsky the color
blue had a spiritual significance
rivaled by no other color. He
believed that blue is an invita-
tion to the infinite that awakens
a desire for the supernatural.

Blue mountains appear in
several Kandinsky paintings
as a recurring motif, which
seems appropriate consider-
ing that mountains were
once regarded as natural
temples that reached into
heaven. In *Blue Mountain*,
the dreamlike landscape
expressed through brilliant
colors and simplified form
is dominated by a blue
mountain rising in the back-
ground. Although Kandinsky
acknowledged that optically
the color blue recedes, the
blue mountain in this paint-
ing, just like the one in his
Angel of the Last Judgment,
does not appear to recede
into the distance as moun-
tains usually do; rather, the
mountains in both of these
paintings appear to charge
into the center of the paint-
ing, inviting the viewer to
explore the surrounding
forms and colors.

In 1911, together with
German painter Franz Marc,
Kandinsky founded the Blue

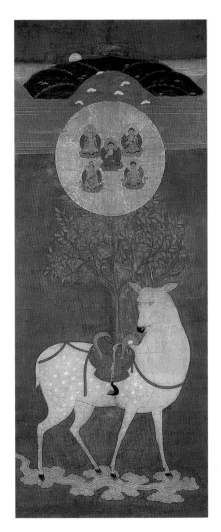

This ancient hanging scroll
from Japan uses blue to achieve
a mood of serenity.

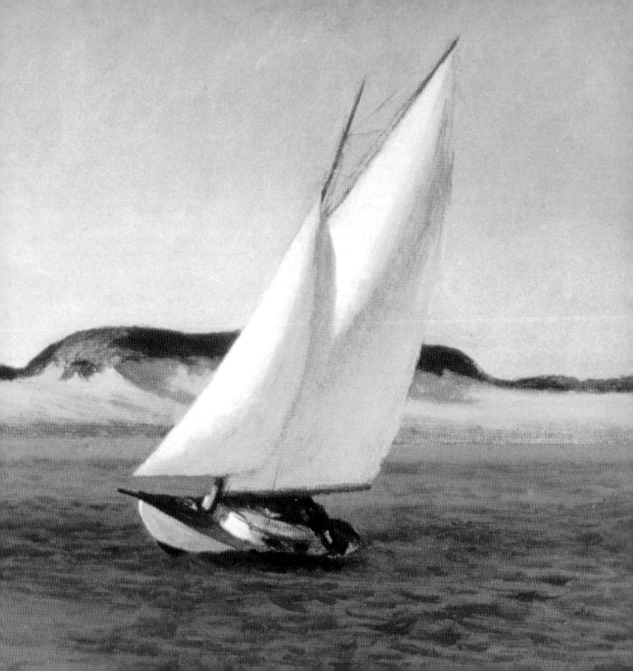

Rider (*Blaue Reiter*) movement, named after the title of one of Kandinsky's paintings, *Le Cavalier Bleu*. The members of the Blue Rider movement were united in their belief that colors have spiritual and emotional significance, especially the color blue with its mysterious and introspective character.

IMPRESSIONISM AND INDIGOMANIA

Impressionist painting originated in France in the mid-1800s and was strongly influenced by Michel-Eugene Chevreul's theories of color harmony and contrast. Chevreul discovered that different colors in close proximity modify one another, that complementary colors (those opposite each other on the color wheel) create the strongest contrasts, and that all colors in isolation have faint halos of their complementary colors. The Impressionists explored these ideas in their style of painting. Their palettes included mostly pure, unmixed colors and a notable absence of black. They applied paint to the canvas in patches of color that, just as Chevreul predicted, altered the appearance of each color through contrast, and were "mixed" by the retina of the observer's eye rather than that of the artist.

The dominance of blues and violet blues is one of the color signatures of the Impressionist palette. Many Impressionist paintings rely on blue's atmospheric qualities to depict the play of light. In Monet's *Woman with a Parasol*, the whites of the woman's dress have taken on the pale blue hues of the sky; similarly,

Monet claimed that the true color of the atmosphere was indigo.

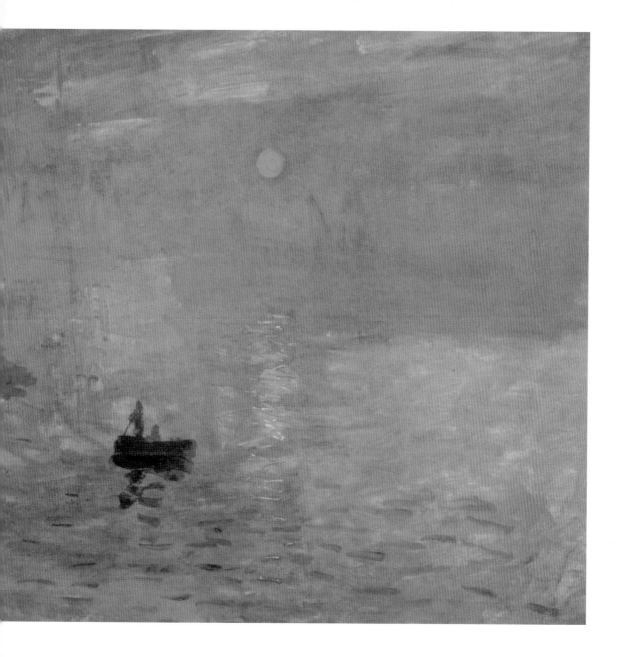

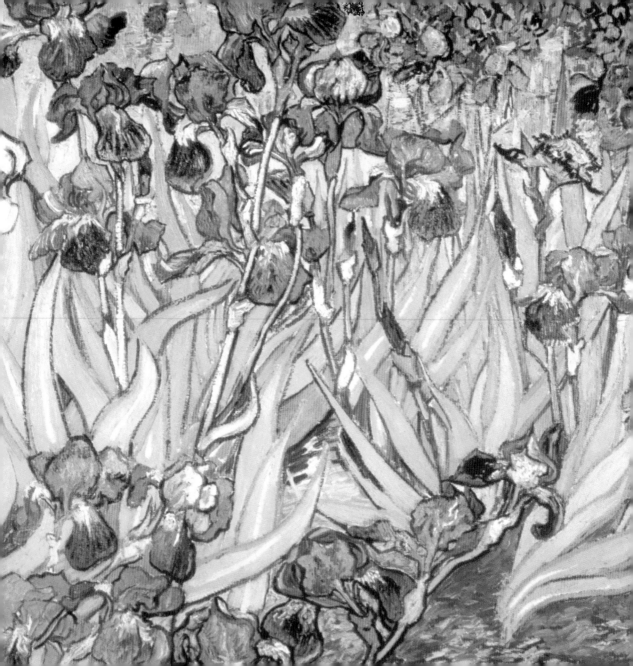

In this painting, Van Gogh celebrated one of Nature's perfect blues—that of the iris.

in his *Blue Boat*, the blues of the sky and water seem to be reflected in the boat as well as the dresses of the women. Light is everywhere—and light is blue. Many of Paul Cézanne's bathing paintings present sky and water as if they were without boundaries, crashing into each other with colored waves of light and water. Cézanne's sky and water palette primarily included blue, green, and white, which, when combined, assumed a transparency that let the water and sky exist simultaneously in the same space.

Critics complained about the Impressionist preference for pure pigments, and were particularly uneasy with their "overuse" of colors from the cool end of the spectrum. The prevailing critical wisdom had favored a predominance of warm hues. Eventually, the term "indigomania" was coined for the Impressionists' "unhealthy" passion for blues. Monet willingly acknowledged his personal indigomania; however, he made no attempt to change his ways, and claimed with great enthusiasm that he had discovered the true color of the atmosphere, and it was, indeed, indigo.

THE QUEST FOR THE PERFECT COLOR: WEDGWOOD BLUE

One of the most famous uses of the color blue in the decorative arts is to be found in the blues of Wedgwood pottery, created by Josiah Wedgwood, an Englishman skilled in pottery, chemistry, and antiquities. Around 1774, Wedgwood developed a type of unglazed stoneware called jasper, which he first created in white. Wedgwood searched steadily for the perfect color for his new stoneware and eventually created the blue for which he later became famous.

Even today, despite additions to the Wedgwood palette, jasperware continues to be best known for its original blue hues, which range from deep blue to the chalky, stately blue known as "Wedgwood Blue."

PICASSO'S BLUES

Spanish artist Pablo Picasso is considered by many to be the greatest and most influential artist of the twentieth century. From 1901 to 1904, Picasso's paintings were dominated by pervasive blue tones, and consequently, this time is often referred to as his "blue period." During this period Picasso described blue as "the color of all colors," and his palette supported his proclamation. He painted outcasts, beggars, and the elderly in an artistic statement that was not only a portrait of universal despair but also an expression of his own feelings of isolation. During his blue period, Picasso often preferred to paint at

night—a time he associated with the color blue—and he created one of his first blue paintings with a paintbrush in one hand and a flickering candle in the other. In 1901, he painted *The Tragedy* in reaction to a friend's suicide. *The Tragedy*, which portrays a barefoot family, blue and shivering, standing on a desolate blue shore, has been described as the coldest of Picasso's paintings. In *The Ascetic*, an emaciated elderly man sits in front of an empty plate. The intense blue hues create a chilling atmosphere of despair and hunger—both physical and spiritual. In other blue period paintings such as *The Old Guitarist*, melancholy borders on poetic resignation; and in *Crouching Woman*, the woman who is the subject of the painting could be suffering or harboring a secret. As in many of the paintings from his blue period, Picasso left the mystery unexplained in *Crouching Woman*.

INTERNATIONAL KLEIN BLUE

The French artist Yves Klein was best known for his mono- chromatic paintings in which the canvas was uniformly covered in a single color. The objective of Klein's monochro- matic painting was a deperson- alization of color through the elimination of subjective emotion. Klein believed that a canvas completely covered with a single color no longer expressed the personal emotion of the artist but only the exis- tence of the color. His interest in monochromatic painting led to his "blue period" in 1955. He developed his famous shade of blue, which he named "International Klein Blue," and used it to color most of his paintings, prints, and sculptural pieces during this period.

In a 1959 lecture presented at the Sorbonne in Paris, Klein explained his passion for blue: "Blue has no dimensions, it is beyond dimensions. . . . Blue suggests at most the sea and sky, and they, after all, are in actual, visible nature what is most abstract."

Klein created art through a variety of nontraditional methods, including the use of human body imprints, which he called "anthropometries." One of his anthropometric exhibitions featured nude women painted with Interna- tional Klein Blue. To the accompaniment of extremely minimalist music composed by Klein (*Symphonie monotone* was an alternating sequence of a single note sustained for ten minutes followed by ten minutes of silence), these blue women were dragged like paintbrushes across canvasses spread on the floor, leaving behind blue trails and body imprints.

The blue sea beckons from Thomas McKnight's fantastic pavilion.

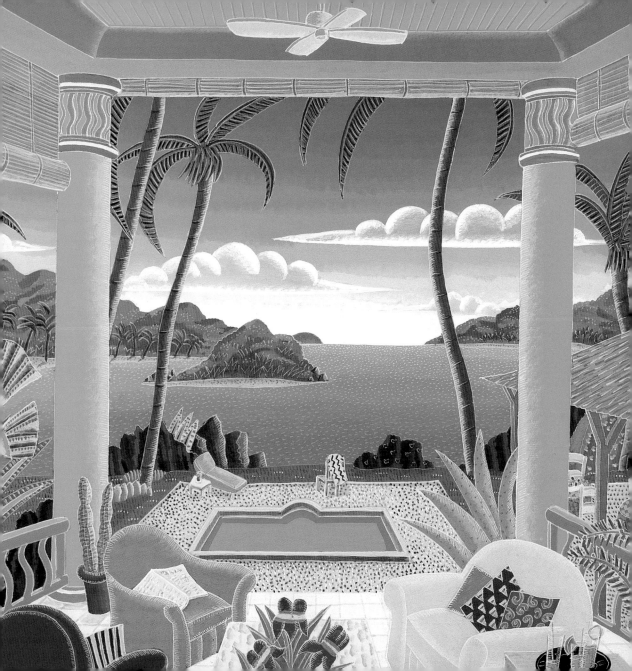

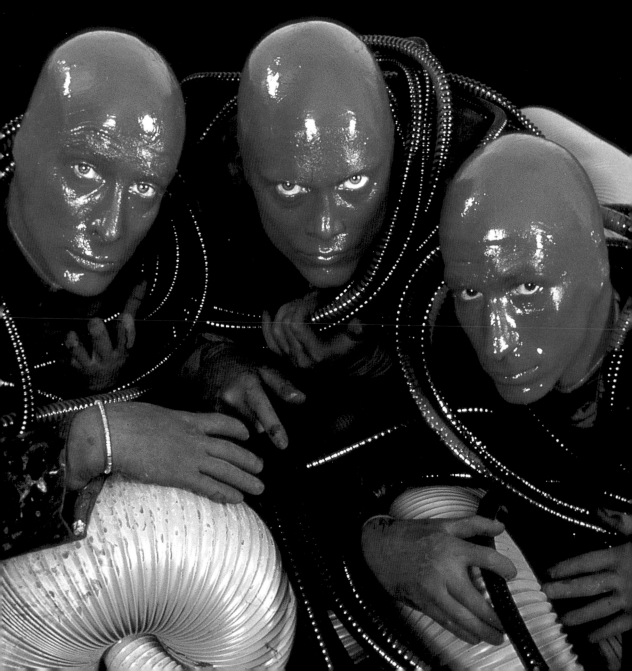

BLUE FILMS

Although the slang term "blue movie" refers to a film regarded as having obscene content, the color blue has inspired contemporary filmmakers to explore the more spiritual aspects of blue's character. *Blue,* an experimental film by British filmmaker Derek Jarman, is simply, literally blue—it features a solitary visual image of an illuminated blue screen for seventy-five minutes. The film is an autobiographical account of Jarman's journey toward blindness and death from the AIDS virus. The unchanging, unrelentingly blue screen represents Jarman's impending death as well as his salvation, while the aural imagery navigates the audience through his final days. Another filmmaker, Krzysztof

When asked why they chose blue, the Blue Men have mentioned everything from blue's emotional complexity to its connotations of freedom.

Keislowski, made three films inspired by the three colors of the French flag: *Blue, Red,* and *White.* In *Blue,* Keislowski uses blue lights, sets, and costumes, but it is primarily the alienation and depression of the main character, who has lost her husband and child in a car accident, that colors the film blue.

THE BLUE MAN GROUP

Not to be confused with the mythical Blue Men of Minch, the Blue Man Group is an off-Broadway theatrical experience that evolved from a bald, earless, blue character created by Matt Goldman, Phil Stanton, and Chris Wink in 1988. The group describes the blue man character as "a curious, gentle being from inner space who wants to 'blesh' with the audience through sound and color." ("Blesh" is a science-fiction term meaning "blend and mesh.") The Blue Man Group performed on the streets and

in a variety of theaters before settling into an extended run of their unusual show *Tubes.* *Tubes* is an innovative combination of comedy, commentary, stunts, music, and audience participation. *Tubes* includes such highlights as the live creation of art from colored balls that the Blue Men chew and spit at canvasses, and a concert created by the amplified chewing of crunchy cereal. Over the years, when asked why they chose blue, the Blue Men have cited everything from blue's emotional complexity to its connotations of freedom.

Blue Architecture

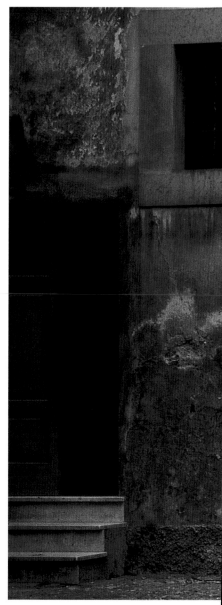

ARCHAEOLOGISTS BELIEVE that not long after the first builders abandoned their caves and built shelters, they colored these structures in much the same way that they had painted their caves. Whether building a simple dwelling or a cathedral, color has been, and continues to be, one of the fundamental concerns of the architect. In many early societies, the coloring of the constructed environment was strongly influenced by the symbolic codes of religion and other cultural institutions. Many cultures regarded blue as the color of heaven and truth; therefore, the roofs and ceilings of structures were often painted blue. The ziggurats of ancient Mesopotamia were built in concentric levels, each painted a different color that represented a particular planet and symbolic code. The higher levels of these spiral temples, as well as the exterior walls, were frequently painted blue, representing specific planets as well as heaven itself. Egyptian tombs and temples had starry blue ceilings, and the architects of Gothic cathedrals continued the tradition by painting ceilings blue to symbolize the kingdom of heaven.

In warm climates where the sun is strong, architectural colors tend to be brighter.

Throughout the Mediterranean, architectural color reflects the blue of the sea and sky.

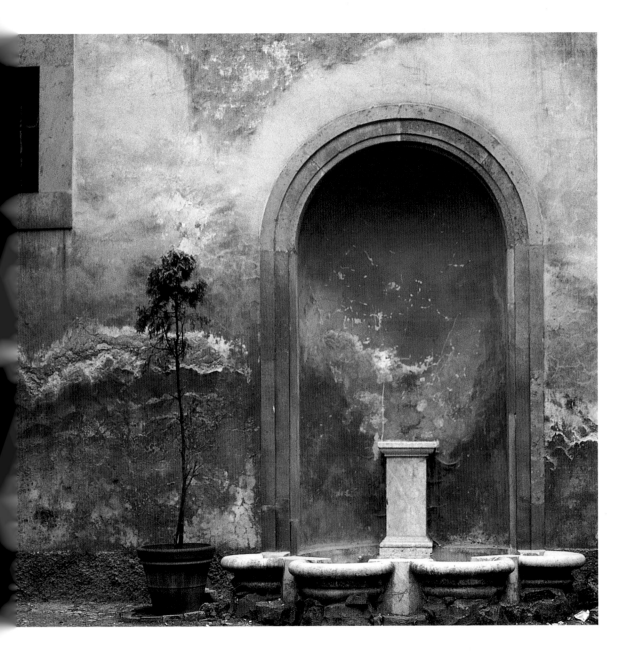

Although the architecture of the Caribbean was originally colored only by the indigenous materials with which it was built, once commercial paints were available, structures were transformed into color reflections of the landscape. Blue—the color of the Caribbean sea and sky—became the dominant color of many structures on the islands. Similarly, the climate of the Mediterranean has inspired some of the bluest architecture in the world. In the Moroccan mountain village of Chaouen, stucco-covered dwellings are painted in layers of blue-tinted whitewash that deepen into brilliant blues after rainfall. In Greece, the blue of the sea and sky is reflected in its flag as well as much of its architecture. Throughout the Middle East, the exteriors and interiors of many Islamic buildings, especially mosques, are tiled in

mosaics dominated by turquoise and cobalt blue. For many cultures throughout the Mediterranean and Middle East, the color blue is still symbolically

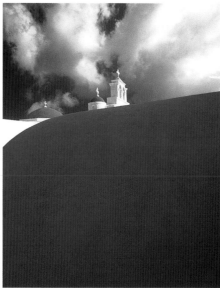

The ceilings and roofs of many different types of religious structures have often been painted blue to symbolize the heavens.

used as protection against evil. Doors, window frames, and exterior ornaments are painted blue to distract and avert the "evil eye."

Architectural blues are not limited to exteriors—blue has been used as an interior color throughout history. Every period had its blue— the Italian Renaissance had the teal blue called Della Robbia; under Madame de Pompadour, France had the chalky Pompadour Blue and the dusty aquamarine color called Sevres Blue; Georgian Blue (a stormy blue-green) dominated the Georgian period, followed by the pale Opal Blue of the Adams brothers and the ever-popular Wedgwood Blue.

Today, historical as well as contemporary colors are available to the architect and interior designer, resulting in a wide variety of applications, motivated by agendas ranging from personal style to historic preservation to functional color. A "functional" color is one that is used for its effects on psychological and

physiological factors. Blue has calming and cooling effects, so it is often used as a functional color in educational and health-care facilities, as well as industry.

DECORATING WITH BLUE

Blue has always been a popular color for interiors. Because blue is often associated with serenity and repose, many consider it to be an appropriate color for bedrooms. Color therapists support this opinion, claiming that the color blue can be a cure for insomnia. Blue is also a good color for bathrooms because of its association with water. Depending upon the specific tint or shade, blue is evocative of a range of emotions. Pale blue is a cool color

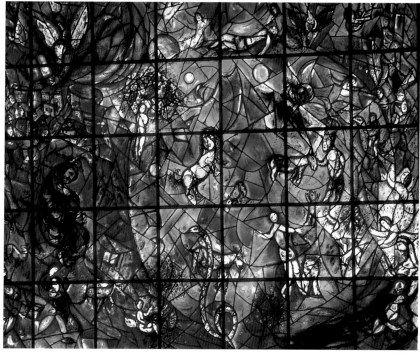

Blue has long been an important color in the art of stained glass. This window, designed by artist Marc Chagall, adorns the United Nations building.

reminiscent of glacial ice. In hot climates, pale blue interiors seem to offer relief from the heat. More dramatically, gray blues, like those seen in a stormy winter sky, are often forbiddingly cold and consequently are best suited as a trim color. Deep blues and blue greens may be warmer and less inclined to evoke the feelings of detachment that blue sometimes conjures. Contrary to popular belief, intensely bright colors need not be reserved for larger rooms—a small room

painted a brilliant sapphire or turquoise blue can have a jewel-like luminosity to it that dramatically exploits the saturation of these strong colors.

Blue is easy to use in combination with other colors. Blue and white is a crisp and refreshing combination that many people associate with kitchens (no doubt due to the popularity of blue-and-white china). This color combination seems to sparkle and works well in bathrooms as well as kitchens because of its association with cleanliness. Blue and yellow, its near-complementary color, are a combination found in nature, such as the blue sky arching over a field of sunflowers. This is a cheerful combination, well suited to children's

rooms and informal spaces. Blue and green, the colors of the earth and sky, create a lively combination that works

Blue and white is a traditional combination that works well in many rooms.

well in social spaces, such as living rooms or dining rooms. Color combinations are not limited to spectral, or "true," colors. For example, a blue-and-green combination could be slate blue and olive green,

sky blue and apple green, or navy blue and malachite.

As an interior color, blue offers the additional advantage of its optical tricks. Blue's receding quality can be exploited to emphasize perspective in a number of different ways. A blue window at the end of a hall or room can create the illusion of increased length, and the width of a narrow room can be visually increased by painting one wall blue. The tradition of painting the ceilings of Gothic cathedrals blue not only represented heaven symbolically, but also emphasized the height of the nave, thereby further establishing the sense of endlessness associated with heaven.

Seasonal Blues in the Garden

The azure petals of the morning glory are a perfect reflection of the deep blue sky.

Blue in the garden is no different than blue anywhere else; like the sky and sea, a bed of blue flowers seems to serenely drift into the distance. Because this color recession creates the illusion of space, a border of blue flowers tends to dissolve garden boundaries rather than define them. This melting of edges can create an enchanting effect of endlessness. However, as dreamy as the spell of an all-blue garden may be, too much blue invites the possibility of sleepy boredom, or even depression, to the same garden. Therefore, even in a "blue garden," most gardeners advise combining blue with other colors.

BLUE IN CONCERT: SEASONAL TIDES OF COLOR

Blue is comparatively scarce in the flower garden, and most flowers described as blue are actually variations of violet. Nonetheless, nature has provided a bouquet of blues for the flower garden, ranging from the sky blues of morning glories and bluebells to the deep, mysterious blues of monkshood and gentian.

Although a range of blue tints and shades bloom throughout the growing season, the following suggestions for blue gardens link an ascending saturation of color with the seasonal progression from spring to late summer. Thus, the approach below assigns soft blues to spring, bright blues to early and midsummer, and deep blues to late summer. The suggested color combinations for each tide of blue create distinct and striking

effects: a cool blue garden for spring; for summer, an Impressionist color scheme of complementary colors; and a celebration of saturated color for summer's finale. These flower and color combinations are just a few of the endless possibilities for using blue in a flower garden, and they are presented only as a starting point for your own creative designs.

Hardiness and blooming times vary according to zone (a geographic area based on minimum winter temperatures) and even local conditions. Check with a nursery or garden club to verify blooming times and to determine which flowers will survive and thrive in your area. *Also note that one of the suggested flowers for the late summer garden is monkshood. This flower is poisonous and should not be grown where children or pets might have access to it.*

A COOL BLUE GARDEN FOR SPRING

This blue, white, and silver garden is reminiscent of the season during which it blooms—it is crisp and cool like the brisk days of early spring. The silvery artemisia provides a perfect foliage framework, and its color adds an intriguing element of reflection to the flower bed. By combining soft blues, such as those worn by the Spanish bluebell, iris 'Wedgwood', forget-me-not, and scilla, with white flowers such as tulips, snowdrops, and windflowers, the blue flowers make a

Nature has provided a bouquet of blues for the flower garden.

BLUE GARDEN FOR SPRING

Spring Blues

Spanish Bluebell
(*Endymion hispanicus* 'Myosotis')

Iris (*Iris* 'Wedgwood')

Forget-Me-Not
(*Myosotis alpestris*)

Scilla
(*Scilla sibirica* 'Altrocaerulea')

Spring Whites

White Tulips
(*Tulipa fosteriana* 'Purissima')

Snowdrop
(*Galanthus nivalis*)

Windflower
(*Anemone nemorosa*)

Silver Foliage

Artemisia
(*Artemisia absinthium* 'Lambrook Silver')

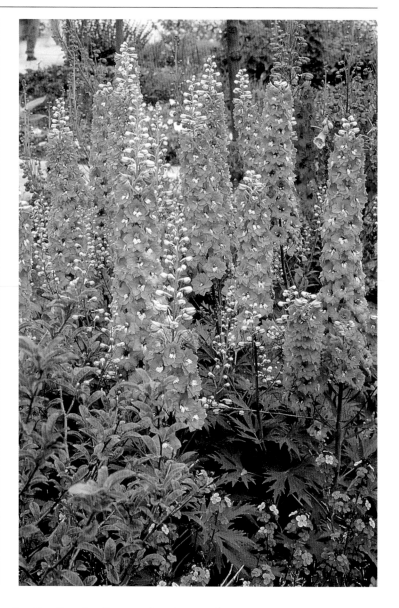

IMPRESSIONIST GARDEN

Summer Blues

Spiked Speedwell
(*Veronica spicata* 'Blue Fox')

Alkanet
(*Anchusa azurea*)

Bachelor's Button
(*Centaurea cyanus*)

Larkspur
(*Delphinium elatum*)

Cranesbill
(*Geranium pratense* 'Johnson's Blue')

Summer Yellows

Lily
(*Lilium szovitsianium* 'Stelladoro')

Evening Primrose
(*Oenothera missourensis*)

Yellow Foxglove
(*Digitalis grandiflora* or *Digitalis ambigua*)

Summer Oranges

Cape Daisy
(*Venidium fastuosum*)

French Marigolds
(*Tagetes patula*)

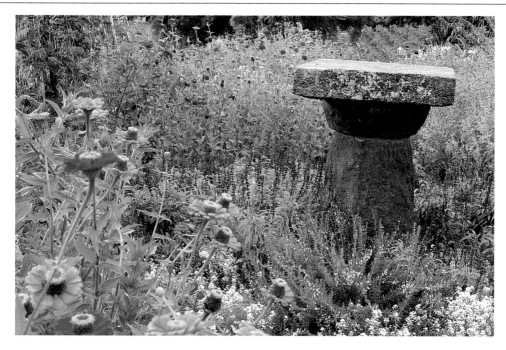

Here, salvia creates a serene oasis of blue in the center of a riot of color.

stronger statement. A nice addition to this color scheme are the pale lemon centers of the windflowers, which add a hint of warm contrast to this cool, harmonious garden. Divide the flowers into

Delphinium provides fountains of rich blue flowers in the summer.

a two-to-one ratio, with the largest proportion blue and the accent flowers white.

A Blue, Orange, and Yellow Impressionist Garden for Summer

Many Impressionist gardens were based on the concept of complementary colors—those

colors directly opposite each other on the color wheel that create the strongest contrasts when positioned together. Therefore, blue flowers were frequently juxtaposed against orange flowers, because blue and orange are complementary colors. Many Impressionists also believed that primary colors contrasted pleasantly with each

other, so yellow, which is both a primary color and a near-complementary color (almost opposite blue on the color wheel) was also frequently juxtaposed with blue. The yellow, orange, and blue contrast has been celebrated not only in the gardens of the Impressionists, but also in their paintings, as Monet's *Flowerbeds at Vetheuil* and Van Gogh's *Irises* (pg. 48) so beautifully illustrate.

Spiked speedwell, alkanet, bachelor's button, larkspur, and cranesbill geranium are bright blue flowers of early and midsummer that glow like sapphires when combined with the orange of cape daisies and French marigolds, and the yellow of 'Stelladoro' lilies, evening primroses, and yellow foxgloves. The orange and yellow flowers also make the blues appear slightly violet, which adds warmth and drama to the garden. Mix the oranges and yellows almost equally, interspersing them in a bed of bright blue.

A VIBRANT FINALE OF BLUE FOR LATE SUMMER

As summer approaches autumn, there is an eye-catching finale of vibrant, deep blue flowers that may be combined with red-purple flowers to create a saturation of color. The intense blues of monkshood, gentian, sage, and balloon flowers are enlivened by the pulsating presence of red-purple phlox, spiked gayfeather, and Italian asters. Although the proportions of colors are a matter of individual taste, a garden is usually more aesthetically pleasing when one color dominates and the others act as accents. Because this is a blue garden, let the blue flowers lead and use the red-purple to break up a deep sea of late summer blues.

The corydalis 'Blue Panda' contrasts well with blue-green foliage.

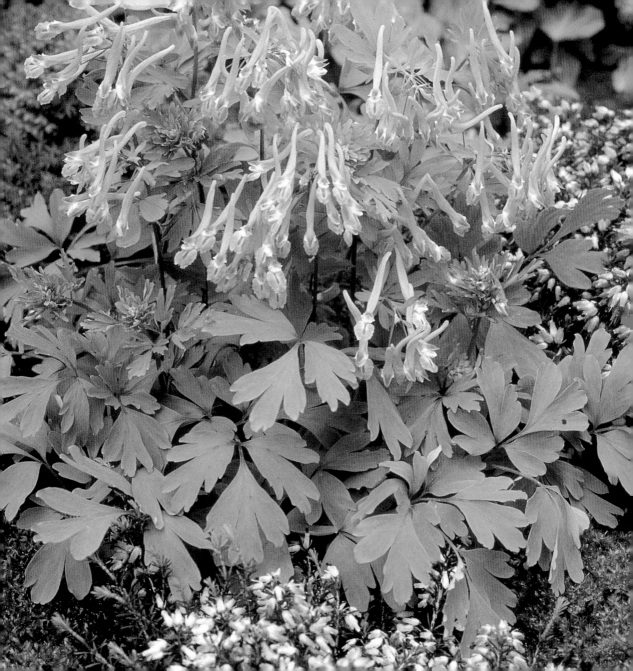

Music in the Key of Blue

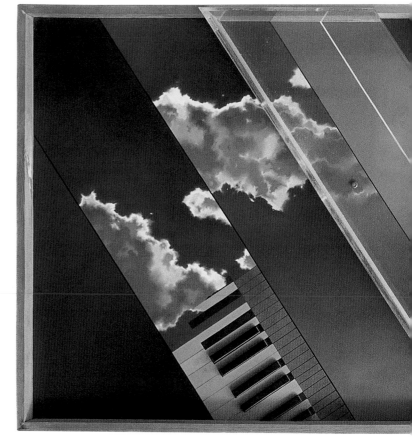

THE FIRST CONNECTION people usually make between the color blue and music is the uniquely American musical genre called the "Blues," a hybrid of African and European musical forms noted for its earthy, melancholy, and mournful sound. The musical Blues are not very different from emotional blues; therefore, Blues' lyrics often deal with loss, grief, and sorrow. The characteristic Blues sound is also "blue" in that it involves scales containing "blue notes," which are slightly flat or off from the correct pitch, just as a "blue" mood is slightly off from a normal one.

However, music in the key of blue includes more than just the Blues. Since ancient times, people have dreamed of discovering a universal harmony that included correspondences between colors and music. Although today we know that there is no direct scientific relationship between colors and specific frequencies of sound or musical pitches, both sound and color are vibratory in nature, and intuitively, sounds and colors can be said to evoke similar moods in the observer. Pythagoras, the Greek mathematician and philosopher, discovered the mathematical relationships between the notes

which he proposed a visual rendering of sound. He later designed a color organ, the Clavessin Oculaire, based on prisms and translucent color strips illuminated by lanterns or candles to flash colors along with musical notes. He assigned blue to the note C and indigo to the note B. Castel's contemporary, the composer Jean-Philippe Rameau, attributed to blue the role of the "fundamental" of all colors, equivalent to the "root" or starting note of a musical scale. (Also ascribing the note C to blue in the mid-1800s was George Field, a British color theorist who sought connections between colors, music, and other arts. In his book *Chromatics*, he wrote of the

of the musical scale and sought to correlate these relationships with colors. In the early 1700s, Sir Isaac Newton conducted optical studies using prisms. Initially identifying eleven colors in the rainbow, Newton later revised the number to

seven, finding a correspondence to the seven notes of the musical scale. In Newton's scale, blue corresponded to the note G.

In 1720, the French Jesuit mathematician and philosopher Louis-Bernard Castel published *La Musique en Coleurs*, in

"melody of colors.") Others have constructed color organs as well. In England, A. Wallace Rimmington developed a color organ around 1893 that had a keyboard like an organ and projected abstract color forms onto a screen as music played. He used deep blue for the note A-sharp. For a time, his color music was a huge success in London.

In the early twentieth century, the Russian composer and mystic Aleksandr Scriabin claimed to "hear" colors in a rare type of sensory blending called "synesthesia." Scriabin composed an orchestral piece entitled "Prometheus, the Poem of Fire" that was performed with a color organ projecting colors onto a screen in time with the music. Significantly, the piece began and ended with the color blue. Scriabin assigned the color "pearly blue" to the note E and "moon-color/sky blue" to the note B, corresponding respectively to "dreams" and "contemplation." He also assigned the color "bright/navy blue" to the note F-sharp, corresponding to "creativity." Scriabin was influenced by the teachings of a nineteenth-century mystical school called Theosophy, which attributed to blue the qualities of "devotion to a

What Color is Bluegrass?

COVERING MUCH OF THE KENTUCKY PLAINS is a ground cover called *Poa pratensis*, commonly known as bluegrass. In the 1930s, while the bluegrass grew on the plains, a new form of music filled the air. Because this new music was associated with Kentucky—the Bluegrass state—it became known as bluegrass music. Performed primarily with the fiddle, banjo, mandolin, and guitar, bluegrass has a fast, happy, two-beat style with a vocal approach similar to early mountain ballads. Just as bluegrass is a blue-green color, bluegrass music evokes the blue of the clear sky above as well as the green of the grass under dancing feet.

noble ideal" and "pure religious feeling." Some people claiming to experience synesthesia have even associated blue with specific compositions and composers—for instance the operas *Aida* and *Tannhauser,* as well as the composer Mozart, have been described as "blue."

By the late nineteenth century, many composers, musicians, and artists had abandoned the attempt to relate color to specific notes and instead sought color correspondences to subjective psychological states or moods. The British composer Arthur Bliss (1891–1975) composed *A Colour Symphony,* based on the heraldic primary colors, of which the third movement was "Blue: The Colour of Sapphires, Deep Water, Skies,

Riding on a Blue Note

When you are in the mood for blue notes, whether azure or indigo, try listening to some of these blue compositions: "The Blue Danube Waltz" by Johann Strauss; "Rhapsody in Blue" by George Gershwin; "La Mer" or "Sirenes" by Debussy; "Jeux d'eau" by Ravel; "The Fountain of the Acqua Paola" by Griffes; "Kind of Blue" by Miles Davis; "Blue" by Joni Mitchell; "Caribbean Blue" by Enya; "Bright Blue Music" by Michael Torke; and "Mood Indigo" or "Riding on a Blue Note" by Duke Ellington.

Loyalty and Melancholy." The Russian abstract painter Wassily Kandinsky, an accomplished cellist and one of the major proponents of abstract art, considered the cello to resemble dark blue, the double bass to be even darker, and the deep notes of the organ to be the deepest, most solemn blue. Kandinsky echoed earlier musical-color analogies in declaring the tone of the flute to be light blue. Similarly, the Swiss composer Joseph Raff held the tone of the flute to be an intense sky blue. The composer Franz Liszt evoked the mood of color in music most eloquently when he said of a performance of his music, "I want it all azure."

Wearing Blue

IN THE RELATIVELY RECENT history of fashion, there have been as many tints and shades of blue as there are meanings —the restrained slate blues of Christian Dior's postwar designs; the optimistic sky blues of the fifties; the informal, faded blue of sixties denim; the deep midnight blue of Ralph Lauren's designs in the seventies; and the muted blues of the nature-inspired Japanese minimalist fashions of the eighties. Psychologically, the color blue usually projects sobriety and conservatism; however, blue can also be rebellious and electric, as typified by the blue of Italian designer Emilio Pucci's psychedelic palette from the

From toddlers to grandparents, no other fashion item has enjoyed as much popularity as blue jeans.

The Story Behind Blue Jeans

PROBABLY NO OTHER SINGLE TREND in the history of fashion has spread as far and wide as has the popularity of blue jeans. Blue jeans are work clothes—ranchers, farmers, and laborers wear them for work; they are symbols of rebellion—James Dean wore them in *Rebel Without a Cause*; and they're sexy— ad campaigns have claimed that nothing comes between a woman and her jeans. It's highly unlikely that seventeen-year-old Bavarian emmigrant Levi Strauss anticipated that his purely functional trousers would come to represent so much to so many. In the 1850s, when young Strauss realized that miners needed durable trousers, he took some of his tent canvas and turned it into overalls. The pants were as rugged as the miners were rough,

and soon the young tent maker had a new career as a tailor. Ten years later, Levi Strauss switched from canvas to denim, a somewhat softer but nonetheless durable cotton twill that originated in the French city of Nimes known as *serge de Nimes*, pronounced "denim." The denim was dyed indigo, and thus jeans became blue. (The word "jeans" is just an Anglicized version of the French word *genes*, the name of the pants worn by Genoese sailors.) Although blue jeans were originally designed for utilitarian purposes, it was only a matter of time before they became a fashion craze. In 1935 an advertisement in *Vogue* magazine featured two women wearing blue jeans. The magazine launched the trend called "western chic," and the rest is history.

THE FOUR SEASONS OF BLUE
What Season Are You?

Spring

Skin
Gold undertone. Pale and/or ivory skin. Peach or rosy cheeks. May tan and blush easily.

Hair
Yellow blond, strawberry blond, honey blond, auburn, red. Later: golden gray.

Eyes
Bright blue to dark blue, green-blue, gold-green, amber, golden brown, topaz. Yellow-gold flecks.

Summer

Skin
Blue undertone (sometimes pink). Fair and/or pale skin. Medium to dark brown freckles.

Hair
Blond as children. May be light brown as adult, ash overtones. Later: blue-gray or silver.

Eyes
Blue, aqua, gray, green, hazel, soft brown. May be cloudy or have white flecks.

Fall

Skin
Gold undertone. Ivory, peach, or golden-beige skin. May be sallow or ruddy. Golden freckles.

Hair
Honey blond, auburn, strawberry blond, brown with red or gold highlights, most true redheads. Later: copper or warm gray.

Eyes
Brown, amber, hazel, green, turquoise. May have golden flecks.

Winter

Skin
Blue undertone. White to rose or beige to dark olive and most Black and Asian skin. Some freckles.

Hair
Mostly dark: medium to dark brown, and black. May have red highlights. Later: silver or gray.

Eyes
Light to dark brown, dark gray, blue, green, gray-green. May have white flecks.

sixties and the Day-Glo blues of the late seventies. Blue is a popular fashion color because it is a color chameleon—gracefully blending into any fashion environment and serving its accompanying style agendas.

THE FOUR SEASONS OF BLUE

In 1942, Susan Caygill, founder of the Academy of Color, developed a concept of personal color harmony that correlates individual coloration with seasonal color palettes. Caygill was inspired by the color theories of Bauhaus artist Johannes Itten, who believed that all individuals have an innate color harmony that can be used to complement and enhance their lives. Caygill developed parameters for determining personal palettes of color that enhance and even improve one's appearance. The personal palettes are determined through color analysis, which

examines hair, eye, and skin coloring. After analyzing these physical factors, a color analyst assigns each individual a

Navy looks good with almost all skin complexions, and it combines well with other colors.

"color-based" season: winter, spring, summer, or fall.

According to color analysts, each season has a palette of blues that are in harmony with particular skin tones. Winter blues are deep, strong, and vibrant and include royal blue, ice blue, Chinese blue,

dark navy blue, and ink blue. Summer blues, such as sky blue, baby blue, slate blue, faded denim blue, Wedgwood, and medium navy, are soft and muted, tending to lean toward grayed shades. Autumn blues range from medium to deep saturation, and lean toward blue-green, such as marine blue, peacock blue, and several shades of teal. Spring blues are light and bright, such as Caribbean blue, turquoise, cornflower, and bright navy blue.

As a soothing and sober color, blue, particularly dark or navy blue, is perfect for the business world, where it represents confidence and sobriety. With the exception of autumn, navy has "no season" —it is a color that can be worn throughout the year by people with winter, spring, and summer coloring. It combines well with other colors and looks as good in linen as it does in silk. Because of its versatility, navy has come to have the status of a "neutral" color.

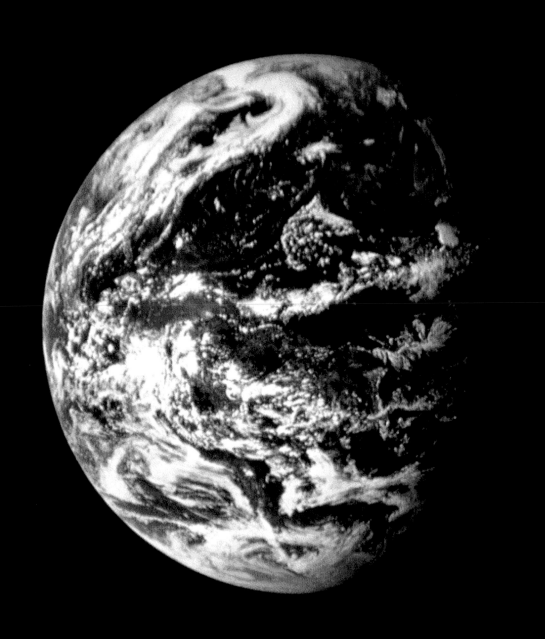

Photographs of Earth taken
from space revealed that
Earth is truly a blue planet.

DISCOVERING BLUE

Elemental Blue

THE BLUE EARTH FROM SPACE

THE PHOTOGRAPH OF THE EARTH TAKEN BY the *Apollo 17* mission was one of the first complete photographs of the whole planet. It proved that Earth is predominantly a blue planet, thanks to the oceans that cover most of its surface. The great depth of the oceans is responsible for absorbing nearly all of the red wavelengths of sunlight, reflecting mostly blue back into space. In the *Apollo 17* photograph, mountains, deserts, and ice caps are also visible, yet blue prevailed as the dominant color. More recently, after the *Voyager*

spacecraft had completed its Saturn mission, astronomers arranged for its robotic cameras to photograph Earth from 3.7 billion miles away. Even from this great distance, Earth appeared as a point of blue light, faintly glowing against the black night of the cosmos.

MINERAL BLUES

Deep inside the Earth, when the conditions are just right, the hot, lavalike rock of the inner Earth slowly cools and solidifies into the rare and highly valued minerals we call gemstones. The precise conditions required to create the different gems vary; however, all are formed under the same general yet rare combinations of conditions: pressure, intense heat, cooling, and solidification. Even when the precise conditions do combine to create these unique minerals, the gemstones are often still beyond our reach. It is only when internal pressures force

the surrounding rock up to the Earth's surface that the gems are exposed.

The quintessential blue gemstone is the sapphire. Even its name means blue, from the Latin *sapphirus*. However, it is likely that the stone actually referred to by that term in ancient times was the blue stone lapis lazuli. The sapphire has been a very highly valued and sought-after stone, prized as much for its beauty as for the powers it was believed to possess. Throughout history, perhaps due to its blue color, the sapphire has been associated with matters of the soul. In Medieval Europe, sapphires were believed to purify the wearer, which led to the tradition in the Catholic Church of cardinals wearing rings in which these blue stones were set. Even as late as the beginning of the nineteenth century, some people thought that sapphires could cure madness. In other contexts, sapphires have been considered talismans and

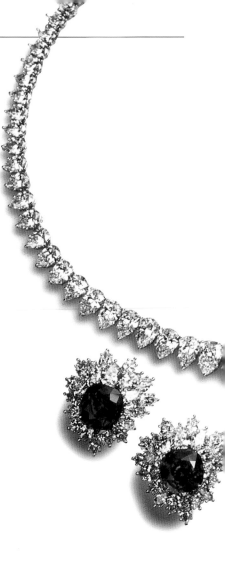

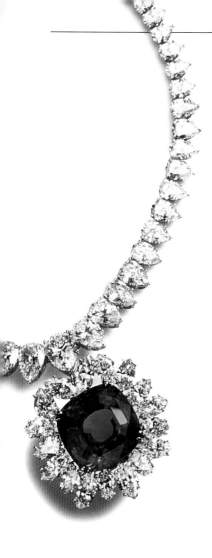

Since antiquity, sapphires have been valued for their beauty as well as for the powers they were believed to possess, such as protection and purification.

amulets performing a variety of magical feats: protection from jealousy, enhancement of psychic abilities, and control over spirits from other worlds.

One relatively rare and very prized form of sapphire is the star sapphire. Called "star" on account of the six-pointed star visible within its mass, the star effect is actually caused by tiny inclusions or "rutilation" within the gem, which reflect light in the star pattern. Among the Sinhalese people of Sri Lanka, the star sapphire is believed to protect the wearer from witchcraft. Sapphires are found in relatively large sizes for gemstones. For example, the largest-known star ruby is 100 carats, while the largest-known blue star sapphire is the Star of India, a 563-carat giant in the collection of the

American Museum of Natural History. Additionally, the Smithsonian has two blue stars, each weighing over 315 carats.

One of the most beautiful blue gemstones, with its watery transparency and glacial ice coloring, is aquamarine. A variety of beryl, aquamarine is from the same family as emerald, its more valuable green cousin. A Brazilian crystal found in 1910 weighed an incredible 240 pounds. Aquamarine is a stone associated with meditation and peace. In esoteric traditions, it was believed to be the sacred stone of the sea goddess.

Not quite considered gemstones are two nonetheless highly prized minerals of the non-refractive variety: lapis lazuli and turquoise. Lapis lazuli, a deep blue stone whose name translates literally to "blue stone" in Latin, was most likely the stone referred to by the ancients as *sapphirus*, rather than the stone we know today as sapphire. Its name derives

from the Persian word *lazhward*, meaning "blue." A form of lazulite, it may be one of the oldest continuously mined stones, the best specimens coming from the 6,000-year-old Badakhshan mines in northeastern Afghanistan. Pyrite is a common inclusion in lapis, adding flecks of golden flash to the magnificent blue stone. It was also a popular stone for decorative purposes in the palaces of tsarist Russia. The pigment known as "ultramarine" is derived from lapis. The name "turquoise" is derived from the word "Turk," referring to the eastern Mediterraneans who brought the sky blue stone to Europe from the Middle East, where it had been used for thousands of years since before the time of Egypt's First Dynasty. Turquoise was also a very significant gem in ancient

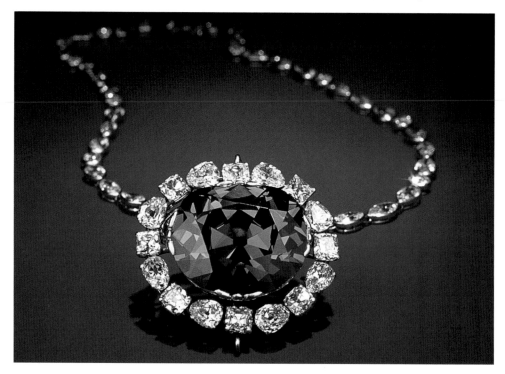

The Hope Diamond is believed to have first been used as an eye in the statue of a Hindu goddess. After being stolen, it passed through many hands, supposedly causing bad luck to whomever possessed it.

Mexican cultures. Other peoples fascinated by turquoise were the Chinese, Tibetans, and Native Americans.

The rarest of all blue gemstones—the blue diamond—is best known for one majestic specimen that gave rise to one of the most popular legends—the Hope Diamond. The steel blue stone was said to have originally been used as an eye in a statue of a Hindu goddess, and it was said to be cursed by the goddess after being stolen by a Hindu holy man. During its rather checkered career, the Hope Diamond passed through the possession of royalty, millionaires, and others—all of whom coincidentally suffered while the diamond was in their possession. After hundreds of years of changing hands from one unlucky owner to the next, leaving a trail of death, disaster, and insanity in its wake, in the middle of the twentieth century the Hope

Diamond was donated to the Smithsonian Institution, where it apparently hasn't done any damage for quite some time.

As sunlight travels to Earth, it passes through atmospheric particles that absorb most color wavelengths but scatter the short wavelengths of blue. Thus, the sky appears to be blue.

THE BLUE SKY

The molecules of oxygen, ozone, nitrogen, carbon dioxide, water, and dust that make up Earth's atmosphere absorb, reflect, and scatter the light

from the Sun. The light from the Sun is white, composed of all the colors in the spectrum. As sunlight passes through the atmosphere, the molecules absorb most of the long wavelength colors, leaving the short wavelength of blue to be scattered as the blue of the sky. Thus, the atmosphere is the crucial factor in the phenomenon of the blue sky. In contrast, the Moon has no atmosphere; therefore, the Moon's sky is black. Our night sky is also considered to be black. However, scientists determined that the color of the night sky is also blue whenever there is at least some moonlight penetrating our atmosphere. Because moonlight is merely reflected sunlight, the same process of light scattering is at work at night as during the day.

Beyond the Earth's blue sky is a universe filled with blue phenomena. In his book

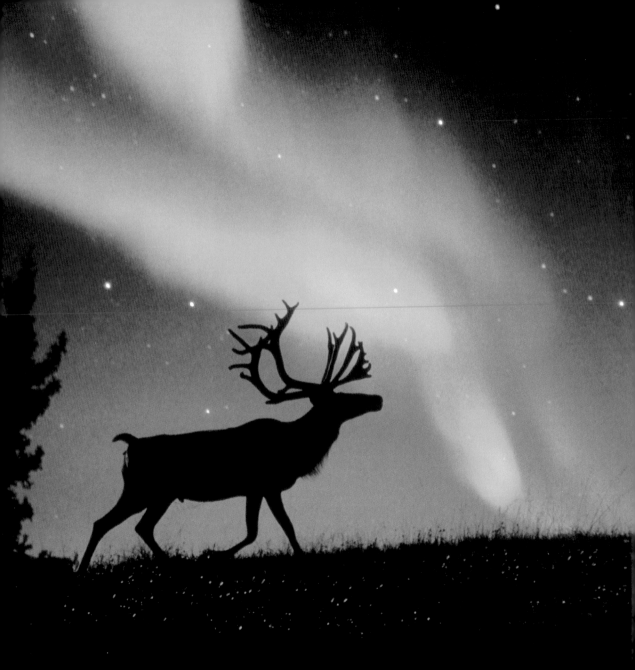

Pale Blue Dot, astronomer Carl Sagan hypothesizes about the skies of other planets. He points out that our Moon, most of the satellites of other planets, and even the planet Mercury are unable to retain their atmospheres because of their weak gravities. Without atmospheres to scatter and thereby "color" light from the Sun, the light reaches their surfaces unimpeded and their skies are black, like the deep blanket of space. Planets with atmospheres inspire Sagan to make guesses about their skies. Mars may have a salmon-colored sky and Venus a sunset-red sky. Although Earth has always been considered the blue planet in our solar system, Uranus and Neptune appear to have blue skies as well. Until recently, the blue skies of these planets were believed to be the result of light scattering within the helium, hydrogen, and methane composition of their atmospheres. However, recent data from the *Voyager* space probe suggests that abundant amounts of a mysterious blue substance may exist.

The blue above us isn't limited to planets. There are displays of the aurora borealis, blue stars, blue shifts, and mysterious blue galaxies. The aurora borealis is a light display caused by the collision of solar particles with air molecules. The colors of auroras are most often blue and green, and less frequently red or pink. Auroral luminosity has been described as having a variety of forms, including ribbons, patches, curtains, arcs, rays, bands, and coronas. Because of its mysterious beauty, the aurora has captured the imaginations of many cultures throughout history and appears in the mythology of the Scandinavians, English, Irish, and Native Americans.

A blue star is a young, hot star. The light colors of stars also indicate the presence of specific elements, with blue indicating oxygen. A blue shift

The Blues of the Sea and Sky

WE SEE COLOR WHEN WAVE-lengths of light pass through our eyes and are interpreted by our brains. However, before the wavelengths reach our eyes, they interact with the environment. A colored object has its characteristic hue because it absorbs only those wavelengths of light that can interact with its particular arrangement of atoms. The remaining wavelengths are reflected by the object, pass through our eyes, and are registered as color by our brains. When the object is comprised of ordered molecules, as is the case with most solid objects, light is reflected in a fairly predictable pattern and color appears constant. The molecules of water and air, however, are somewhat less ordered and therefore interact with wavelengths of light by scattering them rather than reflecting them. The wavelengths of light that have the fastest vibrations, such as violet and blue, are most easily scattered. Thus, the sky and sea are blue.

happens when the frequency—and therefore color—of light changes from the red end of the spectrum to the blue. A blue shift is an indication that the light source is moving toward the observer. Astronomers measure the blue shift of light from stars to determine their velocities. A recent image from the Hubble Space Telescope provided information that suggests that spiral and elliptical galaxies such as the Milky Way may not be the rule but the exception. The information gathered from the Hubble Telescope suggests that irregularly shaped blue galaxies may greatly outrank the more familiar Milky Way-type of galaxy. The blue hue of these mystery galaxies indicates that they are comprised of hot, young stars. The blue galaxies are particularly plentiful at distances of three to eight billion light-years away, which means that they represent a time in the history of the universe when it was roughly half its present age. Puzzling to the astronomers is the strange absence of blue galaxies in the present, closer to our own galaxy.

BLUE WATER

"Everything originated in water," wrote Goethe, and as far as life on Earth is concerned, he was correct. Life on Earth originated in the primordial seas that covered most of the planet following its formation. Even today, water still covers 70 percent of the Earth's surface, which is why it appears as the "Blue Planet" when seen from space. The human body—just one of billions of organisms to emerge from the water—is comprised of the same water-to-solid ratio as Earth: we are 70 percent water. Our bodies are like mobile oceans, carrying proof of our

Part of the pleasure of swimming must include being enveloped in the blue water.

The mysterious depths of the sea are an often dreamy, sometimes eerie, ultramarine blue.

ancient aquatic origins in our salty blood, sweat, and tears.

Although we know that the water from which we emerged is not blue but transparent, in our mind's eye water is blue. Nature designed air and water to scatter blue wavelengths, and this trick of light gave rise to the archetypal image of blue water. Everyone knows that water can be grey, green, sometimes red, and even "wine dark" as described by the ancient Greeks, but water is first and foremost blue. The specific shade of blue depends on the source, location, and activity of the water. Quiet water surrounding the white sands of a tropical island is a bright turquoise blue; standing on that sand staring out to sea, the distant water deepens into a sapphire blue; and the frothy waves of the same ocean

during high tide take on a greenish cast that is sometimes described as "seafoam blue." The mysterious depths of the sea are an often dreamy, sometimes eerie, ultramarine blue; the surface of the northern seas are a steely blue; the mist exhaled by a roaring mountain waterfall is a soft gray-blue; glacial ice is a cold, ghostly blue; and the ephemeral crystals of frost and snow glitter with the scattered blue of the sky.

The 10,000-Degree Kelvin Blue Flame

One of the great ironies of color symbolism is that red is thought of as a warm color and blue a cold color. Throughout history, the average person's experience of familiar natural phenomena certainly validated these associations. The Sun is often yellow, orange, or red, and ice and snow have a bluish cast. Yet science has demonstrated that blue stars are hotter

than red stars, and blue flames are hotter than red flames. Color temperature is based on the principle that when matter is heated, it gives off light of different colors depending upon its temperature. At lower temperatures, the color of light emitted is red; with continued heat, the light turns white; and up there at 10,000 degrees Kelvin—a unit of temperature measurement—the light emitted from a heated body is blue.

The color blue and fire have had a natural partnership in the ancient craft of fireworks, or pyrotechnics, which means "fire arts." However, the color in blue fireworks isn't caused by high temperatures but by metallic salts. Most fireworks displays are created by starting powder that ignites and sets off bursting powder, which ignites metallic salts that give fireworks their spectacular colors. The metallic salt responsible for blue fireworks is copper.

The Living Kingdoms of Blue

Perhaps it is because nature expended so much of the color blue on the sea and sky that it had relatively little left over for the animals and plants. Nonetheless, the blue animals that populate our planet seem to make the most of their coloring—whether they are blue from head to tail like the brilliant blue tangs that school in indigo clouds over West Atlantic reefs, or are just detailed in blue like the bewildered-looking, blue-footed booby bird. Plants are no exception to nature's celebration of blue. Whether the soft whisper of blue on wild flax or the blast of blue projected through the trumpetlike petals of Virginia bluebells, blue plants rarely escape our notice.

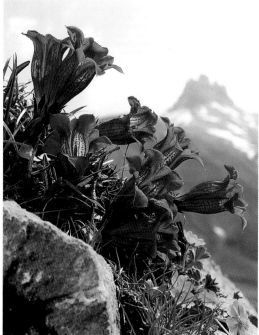

BLUE IN THE PLANT KINGDOM

Truly blue flowers are even rarer in the wilderness than the greenhouse, and one of the rarest blues in the flower kingdom is that of Tibet's wild blue poppy. In 1913,

These stemless gentian flowers are proof that plants are no exception to nature's celebration of blue.

two military men, Lieutenant Colonel Frederick Bailey and Captain H. T. Morsheaf, embarked on a cartography expedition in the Tibetan frontier. Although Bailey was not a botanist, he had an interest in natural history, and when he stumbled upon a meadow filled with alpine flowers, he discovered the blue poppy. Bailey described the blue poppies as four to five feet tall, topped with sky blue blossoms comprised of four large petals that framed a center of yellow. It wasn't until ten years later, in 1925, that a professional plant

collector returned to the region to collect seeds and distribute them to the horticultural community in England, where the blue poppy enjoyed instant popularity.

Not as rare in distribution but with far more fleeting a bloom is the Asiatic dayflower, which has flowers that bloom for only one day. Its flowers are comprised of two round deep blue petals and a much smaller white petal. Another

The gentian family of flowers includes over a thousand different species.

blue flower, considered one of the most striking of its species, is the fringed gentian, which has softly fringed petals and a vibrant blue color. Each slender stalk supports a single tubular flower that opens in the morning and closes at night. Ancient botanical lore claims that the roots of the gentian have valuable medicinal qualities. The harebell, also known as Scottish bluebell, has drooping, blue, bell-shaped flowers.

The delicate blue flowers of viper's bugloss are not a reflection of its name but rather a description of the shape of its seeds, which resemble the heads of snakes.

In dried form this plant was believed to be a remedy for

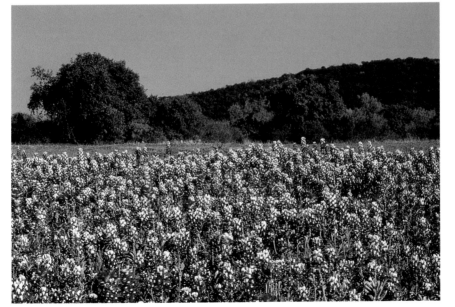

A tall, regal plant with deep blue flowers, this species of lupine, the Texas Bluebonnet, is the official state flower.

snakebite. The pale blue flowers of Jacob's ladder look like the steps of a ladder—an allusion to the ladder to heaven seen by Jacob in his dream.

Besides flowers, there are many blue seeds and berries, such as blueberries, the seeds of the bluebead lily, and the grapelike clusters of blue seeds belonging to the carrion flower. The "berries" of the juniper tree are a chalky light blue color. Although they are called "berries," in fact they are actually cones, as the juniper is a conifer, or cone-bearing, tree. The "berries" are aromatic and resinous. In all its varieties, the juniper has the widest native distribution of any conifer in the world. The berries are used in the distilling of gin, which, if consumed in excess, may lead to the "blue ruin" of

alcoholism, or at the very least, the "blue devils" of a hangover.

BLUE IN THE ANIMAL KINGDOM

In the animal kingdom, the color blue is predominantly structural rather than pigmentary. This means that the blueness is a result of how light reflects and refracts off of the

Many poisonous animals are brightly colored, such as this pair of poison dart frogs.

microscopic structures of the surface of the animal's body, rather than a reflection of pigment embedded in its body

covering. A few crabs, marine snails, and other animals are blue because of blue pigments, usually produced by chemicals in the animal's diet, but most of the blue in the animal world is structural.

Structural blue is often called "Tyndall blue" after the Victorian scientist John Tyndall, who explained that the sky is not really blue at all but just appears to be blue, due to the scattering of blue light waves by particles in the atmosphere. "Tyndall blue" is frequently used to describe all such structural blue phenomena, including structural blue animal coloration and blue eyes—in humans as well as in other animals. So, if it weren't for the dance of light on the surfaces of scales and feathers, there would be very few blue animals.

In Maurice Maeterlinck's 1909 drama, *The Blue Bird*, children of a woodcutter search for the "blue bird of happiness." The children look everywhere for the bluebird, but each time they think they've captured it, the light of day reveals that the captive bird is not blue. At last, when they give up and return to their home, they discover that the bluebird—and happiness—has been there all along. Maeterlinck's choice of a bluebird as the symbol for happiness was not arbitrary—blue-colored birds are symbols of good luck in many cultures. Moreover, because the bluebird's coloring is structural rather than pigmentary, this bird's blue is as elusive as happiness itself.

There are only three species of bluebirds in North America. The mountain bluebird, which is native to North

The peacock's exotic plumage includes the iridescent blue eye at the tip of each fan feather.

America, lives in open meadows, often at very high elevations. It is the cerulean voice of early spring—the true blue promise for warmer, sunnier days—and the only completely blue bluebird. Other bluebirds,

such as the eastern and western bluebird, have radiant blue plumage on their wings and tails, with reddish necks and chests. Of these three bluebirds, the one that lives farthest from human populations at the highest elevations is the bluest.

Peacocks—another bird with structural coloring—are members of the pheasant family. They are native to India, where they live in deciduous tropical forests. The peacock is best known for the large, spectacular fan sported by the male of the species. The fan consists of about 150 multicolored feathers that are an important part of an elaborate, cocky courtship display, used to attract a small harem of females. At the tip of each fan feather is an

iridescent blue ring—an "eye spot"—that matches the brilliant iridescent blue of the peacock's breast. In Greek mythology, Pan gave a peacock

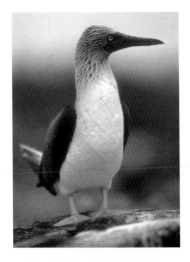

The blue feet of the booby play a prominent role in courtship.

to Hera, who sprinkled the one hundred eyes of the slain giant Argus on the peacock's tail plumage, thereby creating its magnificent feather "eyes."

A striking and somewhat amusing example of pigmentary blue in the avian world occurs in the bright blue feet

of the blue-footed booby. The blue-footed booby is a goose-sized coastal seabird ranging along the Pacific coast of the Americas, from northern Mexico to northern Peru. Both males and females sport bright blue feet that have a prominent role in courtship dancing. However, the flamboyant blue feet do more than just enhance the booby's sex appeal; they play an important role in the bird's family life—boobys use their feet to warm their eggs, spreading the feet like big blue mantels over the clutch, which is placed directly on the ground, without a nest. As a result of their ungainly dancing, bemused facial expression, and apparent fearlessness when handled by humans, the blue-footed booby was named by sailors for what the sailors interpreted as the bird's stupidity. As for the booby's name for sailors, we'll never know.

Elsewhere in the world of blue are the shimmering jewel-like wings of the morpho

butterflies—one of the most spectacular sights in Central and South America. Some of these breathtakingly blue butterflies look like slivers of the sky with wings; others look like soaring sapphires. Most morphos feature iridescent and opalescent blue hues, colors that are nearly always structural. These colors result from the way the wings' surface structures reflect and refract light. As the wings move, the colors change, ranging from indigo to electric blue. The Chinese associate the spirited movements of the butterfly with the pleasures of life,

Most morpho butterflies have brilliant iridescent and opalescent blue hues.

and nowhere does this metaphor seem more apt than in the blue flashes of the morpho in flight.

The marine world is one of the most colorful environments on the planet, and coral reefs in particular contain a lion's share of that color. Reefs are resplendent in a panoply of colors, including a generous range of blues: the cyan of blue hamlets, the turquoise of blue angelfish, the salvia blue of blue tangs, the cathedral blue of the blue chromis, the bright blue stripes and highlights of queen triggerfish, the indigo blue of midnight parrot fish, and the cerulean blue of the blue parrot fish. Swimming in deeper waters are the fast moving bluefish, whose bloodthirsty feeding habits rival those of the piranha, and the elegantly streamlined blue shark, considered the most graceful of all sharks.

When compared with the astonishingly kaleidoscopic world of birds, fish, reptiles, and insects, the world of mammals is primarily colored with earth and neutral tones—except for the male mandrill, the only mammal with truly blue coloring. These intelligent omnivores from the forests of west Africa have vibrant

The marine world, particularly coral reefs, has an abundant variety of blue-colored fish.

multicolored faces, including a scarlet muzzle and orange goatee. But what stands out most in a mandrill's face are his bright blue-ribbed cheeks. As is so often the case in the animal world, the mandrill's extravagant coloring is believed to exist purely for male display.

In addition to pigment and structural color, blue appears in the animal kingdom in yet another form—bioluminescence. There are many different organisms that emit their own light, and much of this "life light" is blue. If you visit the beach at the right time, you might see the surf break in a burst of sparkling blue glitter created by the microscopic bioluminescent organism *Noctiluca miliaris*, whose name means "a thousand night lights." Many deep-sea fish and jellyfish glow an eerie shade of blue, and some species of squid have little blue lights at the ends of their tentacles to attract prey. Clearly, nature relies on the bewitchment of blue.

**The open road, like the color
blue, is an invitation to follow.**

INTO THE
BLUE

ALTHOUGH WATER IS ONE OF THE MOST pervasive environmental blues, it is the sky that truly embodies the essence of blue. The blue arch of the sky is a consistent reassurance that all is well with the world—that blue endures.

We emerged from the primordial blue waters millennia ago, only to raise our eyes toward the vast blue expanse of the sky. And although we return to the water to explore its mysteries, it is the sky that calls us to our futures, into the blue.

Art Credits

Frontispiece: Joseph Cornell, American (1903–1972), *Untitled (Penny Arcade Portrait of Lauren Bacall)*, mixed-media construction, 1945/46, 52.1 x 40.6 x 8.9 cm. Collection of Lindy Bergman 292.1983

pg. 6-7: Jeffrey N. Becom/Photo 20-20. *Blue Steps, Kalymnos, Greece*

pg. 8: Christine Walker. *Cloud Wall #8, Cloud Wall #6, Cloud Wall #7*, 1986. Oil on canvas

pg. 9: Andy Warhol. *16 Jackies*, 1964. Synthetic polymer paint and silkscreen ink on canvas, 80" x 64". © 1995 The Andy Warhol Foundation, Inc.

pg. 10-11: P. I. Productions/Superstock Inc.

pg. 12: (upper) Christoph Burki/Tony Stone Images (lower) Sherri Silverman/Superstock Inc. *Blue Woman in Red*

pg. 13: Sandi Fellman, 1985. *Madame Butterfly*

pg. 15: Frank Devilliers/Tony Stone Images

pg. 16: David Olsen/Tony Stone Images

pg. 17: William Neill Photography. *Point Reyes Beach, Point Reyes National Seashore, California*, 1994

pg. 18: © Comstock Inc./Franklin J. Viola

pg. 20-21: © Comstock Inc./Franklin J. Viola

pg. 22: Betty Hahn. *Starry Night III*, 1975. Cyanotype with watercolors and applied stars

pg. 24: Christopher Boyle/Superstock Inc.

pg. 27: © 1996 Mike and Doug Starn/Artists Rights Society, NY. *L.*, 1986

pg. 28: N. C. Wyeth, American (1882–1945). *The Battle of Westport, October 23, 1864*, ca. 1921. Oil on canvas. Museum of Art and Archaeology, University of Missouri-Columbia

pg. 32: Borromeo/Art Resource, NY

pg. 33: Guido Reni, Italian (1575–1642). *Madonna and Child*, ca. 1628–30. Oil on canvas. North Carolina Museum of Art, Raleigh, Gift of Mr. and Mrs. Robert

Lee Humber, in memory of their daughter, Eileen Genevieve

pg. 34: Tres Riches Heures, Jean de Berry

pg. 38-39: Claude Monet. *Water Lilies*, 1914

pg. 41: Vincent Van Gogh. *Angel*, 1889

pg. 42: From the Collection of the Indiana State Museum and Historic Sites

pg. 43: Kasuga Mandela. Japan, Nambokucho-Muromachi Period, 14th-15th centuries. Hanging scroll, ink, color, and gold on silk, 95.5 x 39.2 cm. © The Cleveland Museum of Art, 1995, Leonard C. Hanna, Jr., Fund 88.19

pg. 44-45: Edward Hopper. *Long Leg*, 1935

pg. 46-47: Claude Monet. *Sunrise*, 1873

pg. 48: Vincent Van Gogh. *Irises*, 1889

pg. 51: © Thomas McKnight. *Mustique Pavilion*. Casein on paper

pg. 52: © Martha Swope

pg. 54-55: Jeffrey N. Becom/Photo 20-20. *Fountain Wall, Orvieto, Italy*

pg. 56: Steven Weinberg/Tony Stone Images

pg. 57: Edward C. Cohen/Superstock Inc.

pg. 58: Courtesy Laura Ashley Home

pg. 59: Courtesy Country Floors

pg. 60: Rosalind Creasy. *Heavenly Blue Morning Glories*.

pg. 61: (background) Michael Javorka/Tony Stone Images (foreground) Rosalind Creasy. *Muscari (Early Giant), Grape Hyacinth*

pg. 62: Courtesy Jackson & Perkins

pg. 63: © Marion Brenner

pg. 65: Courtesy Jackson & Perkins

pg. 66-67: Márton Barabás. Hommage à Presser Gábor

pg. 70: Dale Durfee/Tony Stone Images

pg. 73: Michael Macor, © *San Francisco Chronicle*. Blue Blazer Modeled by U.S. Navy Commander John Henning—Style Counsel

pg. 76-77: Courtesy of Tiffany & Co.

pg. 78: Hope Diamond. Photo by Dane A. Penland. Courtesy Smithsonian Institution, Museum of American History

pg. 79: R. Dahlquist/Superstock Inc.

pg. 80: John W. Warden/Superstock Inc.

pg. 82-83: Christine Walker. *Young Swimmer With Two Passing*, 1980. Oil on canvas

pg. 84: Courtesy Metro Pictures and the Artist Laurie Simmons. *Splash*, 1980

pg. 86: Matty's Collection/Superstock Inc.

pg. 87: (upper) Phil Patrie/National Wildflower Research Center (lower) W. D. Bransford/National Wildflower Research Center

pg. 88: John Netherton/Animals Animals

pg. 89: M. Austerman/Animals Animals

pg. 90: (lower) Michael Burns and Ed Marquand

pg. 91: © Comstock Inc./Franklin J. Viola

pg. 92-93: L. Chiger/Superstock Inc.

Bibliography

Ammer, Christine. *Seeing Red or Tickled Pink: Color Terms In Everyday Language.* New York: Penguin Books, 1992.

Apel, Willi, ed. *Harvard Dictionary of Music: Second Edition.* Cambridge, Mass.: Harvard University Press, The Belknap Press, 1972.

Bassano, Mary. *Healing with Music and Color.* York Beach, Maine: Samuel Weiser, Inc., 1992.

Becom, Jeffrey. *Mediterranean Color.* New York: Abbeville Press, 1990.

Berger, Ruth. *The Secret Is in the Rainbow.* York Beach, Maine: Samuel Weiser, Inc., 1986.

Berlin, Brent, and Paul Kay, eds. *Basic Color Terms.* Berkeley: University of California Press, 1991.

Birren, Faber. *The Story of Color.* Westport, Conn.: The Crimson Press, 1941.

———. *Color: A Survey in Words and Pictures.* Secaucus, N.J.: Citadel Press, 1963.

———. *Light, Color and Environment.* New York: Van Nostrand Reinhold Company, Inc., 1969.

———. *Color & Human Response.* New York: Van Nostrand Reinhold Company, Inc., 1978.

———. *Color Psychology and Color Therapy.* New York: Citadel Press, 1992.

Birren, Faber, ed. *A Grammar of Color.* New York: Van Nostrand Reinhold Company, Inc., 1969.

Bisgrove, Richard. *The Illustrated Gertrude Jekyll: Colour Schemes for the Flower Garden.* Boston: Little, Brown, and Co., 1988.

Caygill, Suzanne. *Color: The Essence of You.* Millbrae, Calif.: Celestial Arts, 1980.

Chevreul, M. E. *The Principles of Harmony and Contrast of Colors and Their Applications to the Arts.* West Chester, Pa.: Schiffer Publishing Ltd., 1987.

Dawson, Aileen. *Masterpieces of Wedgwood in the British Museum.* Bloomington, Ind.: Indiana University Press, 1984.

Faulkner, Waldron. *Architecture and Color.* New York: Wiley-Interscience, 1972.

Fell, Derek. *The Impressionist Garden.* New York: Carol Southern Books, 1994.

Gage, John. *Color and Culture.* Boston: Bulfinch Press, 1993.

Gass, William. *On Being Blue.* Boston: David R. Godine, Publisher, 1991.

Gimbel, Theo. *The Color Therapy Workbook.* Rockport, Mass.: Element Inc., 1993.

Goethe, Johann Wolfgang von. *Theory of Colors.* Cambridge, Mass: The M.I.T. Press, 1994.

Hall, Manly P. *An Encyclopedic Outline of Masonic, Hermetic, Qabbalistic and Rosicrucian Symbolical Philosophy.* Los Angeles: The Philosophical Research Society, Inc., 1977.

Halse, Albert O. *The Use of Color in Interiors.* New York: McGraw-Hill Book Company, 1978.

Herwig, Modeste. *Colorful Gardens.* New York: Sterling Publishing Co., 1994.

Hobhouse, Penelope. *Color in Your Garden.* Boston: Little, Brown, and Co., 1985.

Hope, Augustine, and Margaret Walch. *The Color Compendium.* New York: Van Nostrand Reinhold, 1990.

Hubel, David H. *Eye, Brain, and Vision.* New York: Scientific American Library, 1995.

Jackson, Carole. *Color Me Beautiful.* Rev. ed. Washington, D.C.: Acropolis Books Ltd., 1984.

Jarman, Derek. *Blue.* New York: The Overlook Press, 1994.

———. *Chroma.* New York: The Overlook Press, 1995.

Jekyll, Gertrude. *The Illustrated Gertrude Jekyll: Colour Schemes for the Flower Garden.* Boston: Little, Brown, and Co., 1988.

Jobes, Gertrude. *Dictionary of Mythology, Folklore and Symbols.* New York: The Scarecrow Press, Inc., 1962.

Kargere, Audrey. *Color and Personality.* York Beach, Maine: Samuel Weiser, Inc., 1979.

Kelly, Alison, ed. *The Story of Wedgwood.* New York: The Viking Press, 1975.

Lindsay, Kenneth C., and Peter Vergo, eds. *Kandinsky: Complete Writings on Art.* New York: Da Capo Press, 1994.

Luckiesh, Matthew. *Color and Colors.* New York: Van Nostrand Co. Inc., 1938.

Luscher, Max. *The Luscher Color Test.* Trans. and ed. by Ian Scott. New York: Washington Square Press, 1971.

Lynch, David K., ed. *Atmospheric Phenomena: Readings From Scientific American.* San Francisco: W. H. Freeman and Co., 1980.

Mercatante, Anthony S. *The Facts On File Encyclopedia of World Mythology and Legend.* New York: Facts On File, 1988.

Parker, Julia and Derek. *Parker's Complete Book of Dreams.* London: Dorling Kindersley, 1995.

Porter, Tom. *Architectural Color.* New York: Whitney Library of Design, 1982.

Portmann, Adolf, Christopher Rowe, Dominique Zahan, Ernst Benz, René Huyghe, and Toshihiko Izutsu. *Color Symbolism.* Dallas: Spring Publications, Inc., 1988.

Riley, Charles A., II. *Color Codes.* Hanover, N.H.: University Press of New England, 1995.

Robinson, George W. *Minerals.* New York: Simon & Schuster, 1994.

Sagan, Carl. *Pale Blue Dot.* New York: Random House, 1994.

Simon, Hilda. *The Splendor of Iridescence.* New York: Dodd Mead & Co., 1971.

Sloan, Annie, and Kate Gwynn. *Color in Decoration.* Boston: Little, Brown, and Co., 1990.

Squire, David. *The Complete Guide to Using Color in Your Garden.* Emmaus, Pa.: Rodale Press, 1991.

Stuckenschmidt, H. H. *Twentieth-Century Music.* New York: World University Library, 1969.

Theroux, Alexander. *The Primary Colors.* New York: Henry Holt and Company, 1994.

Varley, Helen, ed. *Colour.* New York: Leon Amiel Publishers, 1980.

Webster, Graham. *The Roman Invasion of Britain.* London: B.T. Batsford Ltd., 1980, 1993.

Weisberger, Edward, ed. *The Spiritual In Art: Abstract Painting 1890–1985.* New York: Abbeville Press, 1986.

Westrup, J. A., and F. L. Harrison, eds. *The New College Encyclopedia of Music.* New York: W. W. Norton & Co., 1959, 1976.

Wilder, Louise Beebe. *Color in My Garden.* New York: Atlantic Monthly Press, 1990.

Willis, Roy, ed. *World Mythology.* New York: Henry Holt and Company, 1993.

Zajonc, Arthur. *Catching the Light.* New York: Oxford University Press, 1993.

Zuckerkandl, Victor. *Sound and Symbol.* Princeton: Princeton University Press, 1956.